S P R A Y C A N A R T

Henry Chalfant and James Prigoff

With 224 colour illustrations

Thames & Hudson

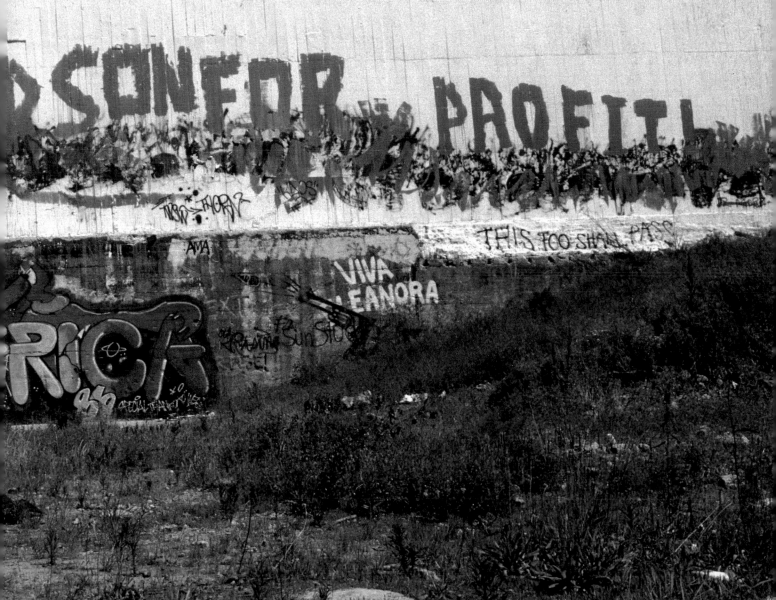

Baby Rock (Philadelphia), 1985

To the spraycan kings of New York City who, in a hostile environment, created and perfected a new art form and, by their example, excited the imagination of young people throughout the United States and across the seas.

First published in the United Kingdom in 1987 by Thames & Hudson Ltd, 181A High Holborn, London WC1V 7QX

www.thamesandhudson.com

Designed by Lawrence Edwards

© 1987 Thames & Hudson Ltd, London

Reprinted 2003

Photographs © Henry Chalfant and James Prigoff with the exception of the following, for which the authors and publishers gratefully acknowledge the photographers named:
Ali, p. 72 (bottom); Peter Balkan, p. 79 (center); Bando, pp. 70/71, 76/77 (both); Martha Cooper, pp. 6, 21 (top), 24 (bottom), 31 (top), 41 (all), 93 (center); Francis Drake, pp. 5, 64 (bottom); R. L. Jackson, p. 9 (center); Joker, p. 67 (top); Martin Jones, p. 65 (top); Lisa Kahane, p. 30 (top); Oliver Kartak, pp. 82 (center left, center right, bottom left), 83 (bottom); Gerhard Klim, pp. 81 (both), 82 (top), 83 (top); Peter de Kruijf, p. 69 (top, bottom right); Jacky Ramier, p. 75 (top right, bottom right); Richard Reyes, p. 61 (top); Maarten Schermer, p. 68 (all except top left); Strax, p. 90 (top); René Westhoff, pp. 86-89 (all); Christian Wolf, p. 80 (bottom).

ISBN 0-500-27469-X

Printed and bound in China

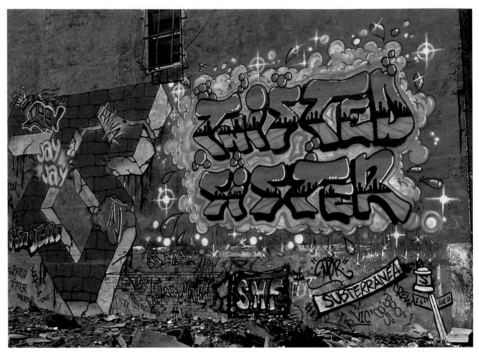

Twisted Sister by C-Mor, Tee Bee, and Vulcan (Manhattan), 1985

On the cover
Front: Detail from *TCA, Lucrezia* by Mode 2 (Paris), 1985
Back: Blade at work (The Bronx), 1986
Half-title page: *Jungle City* by Say, Rade and Side (The Bronx), 1986; *The Wall* by Hec and Tab (Brooklyn), 1983
Title page: *Free South Africa* by Dug and Slimm (San Francisco), 1986

Sak by Sak and Shame (Manhattan), 1986

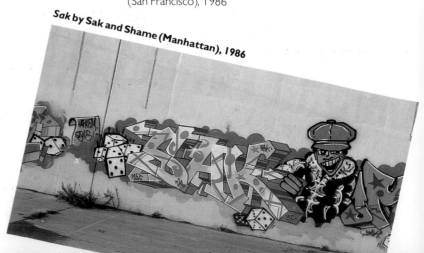

C O N T E N T S

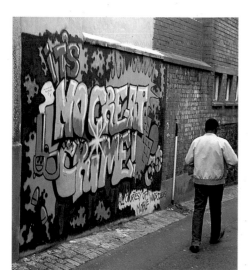

It's No Great Crime! **by 3D (Bristol), 1983**

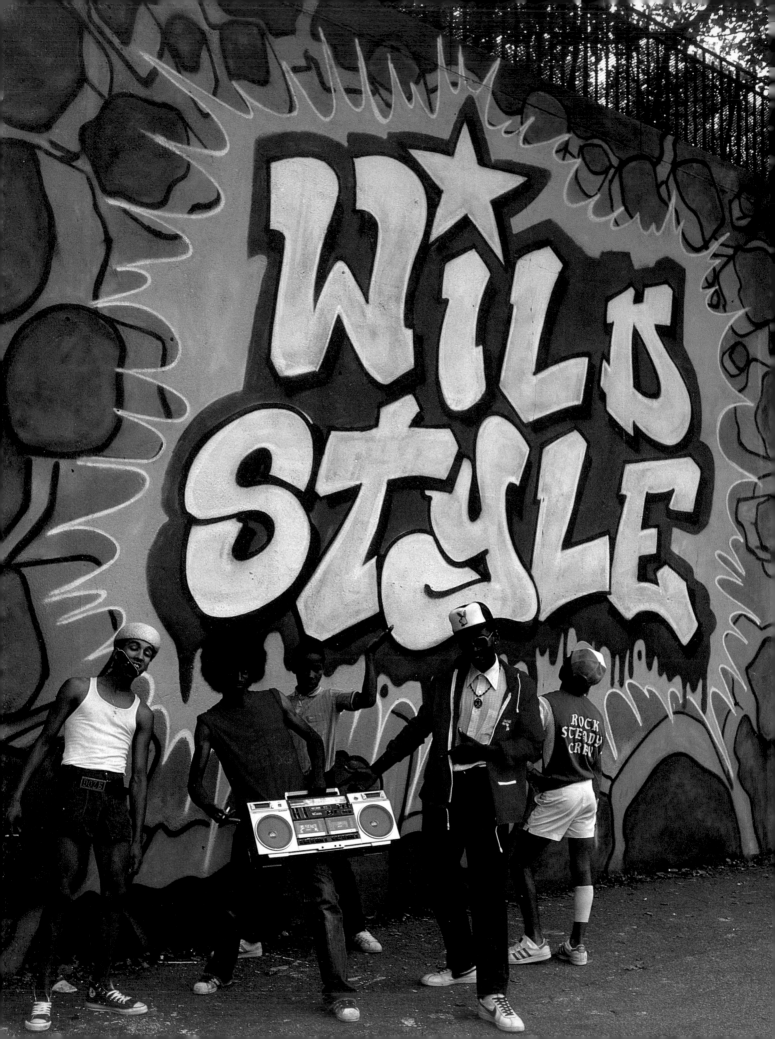

Opposite: **Rock Steady Crew
in front of *Wild Style*
by Zephyr and Revolt
(Manhattan), 1983**

Kids write graffiti* because it's fun. It is also an expression of the longing to be somebody in a world that is always reminding you that you're not. That being the case, it was not at all surprising that when the youth in other parts of the world became aware of what their counterparts in New York City had been up to for years, they were quick to try their hand at spraycan art. The network that once linked the "bombers," "crews," "kings," and "toys" from all the far-flung boroughs of New York City grew to encompass cities from Chicago and San Francisco to London, Paris, and Vienna and around the world to Auckland and Sydney. New York City is still the capital and cultural center of graffiti. It is like Mecca to those who worship at the altar of style.

Not long ago, a writer named Disz showed up in New York with his camera at the 125th Street station of the Broadway Local. Some young writers met him there, discovered his passion for graffiti and brought him to Henry's Manhattan studio. Disz was from Holland but he'd been living in Australia for about three years. There he had first become aware of the new art through such films as *Style Wars* and *Beat Street*. The first leg of Disz's pilgrimage had taken him to San Francisco, where he had looked up Barbara Bodé, the widow of Vaughn Bodé, one of the spiritual ancestors of graffiti and creator of the Cheech Wizard and other appealing cartoon characters. Once in New York, it wasn't long before Disz was exploring the number one tunnel at 145th Street with such current bombers as Say and West One and old masters like Kase 2.

What is a young man from The Hague doing bombing the one line in the 145th Street tunnel with Bodé nudes? The answer lies in the history of an extraordinary cultural exchange which has taken place over the last several years.

In the seventies, travelers from Europe began to bring back news of a most unusual phenomenon taking place on the subways of New York. Somebody was painting the trains with a strange new form of lettering and crazy scenes, transforming the rolling stock of the Metropolitan Transportation Authority into giant mobile comic strips. The Europeans were highly enthusiastic. They had long looked with fascination upon the latest trends in the United States, seeing in the giant across the

Atlantic the image of their own future, like it or not. Those at the cutting edge in cultural and artistic circles are, as a rule, quick to notice anything new on the American scene. One such person was Claudio Bruni, an art dealer from Rome, who first became aware of New York graffiti in a small collection of photographs published by an Italian visitor to New York City. Among the artists with trains represented in this book was Lee Quinones.

In 1978, not satisfied with the staggering number of "top-to-bottom whole cars" that for five years had by sheer numbers, scale, and mastery overwhelmed the competition on the "twos 'n fives," Lee had begun to transform his neighborhood in the shadow of the Brooklyn Bridge into one of the city's most spectacular exhibits of public art. Painting by night, he created a series of unforgettable monumental murals on handball courts: Howard the Duck emerging from a trash can, the guardian lion in the catacombs, the Silver Surfer "hanging ten" in some intergalactic Waikiki, and an apocalyptic vision/warning of the nuclear holocaust that could engulf us all. Fab 5 Freddy brought the *Village Voice* around to see the walls and they ran an article and photographs of the murals. These came to the attention of Claudio Bruni, who flew to New York to find the artist. Shortly thereafter, Lee and Fred were invited to exhibit their paintings at Bruni's Galleria Medusa in Rome. This was for many in Europe their first experience of the arresting beauty and energy of graffiti art.

In 1983, an art dealer from Amsterdam arrived in New York looking for the "writers" he had read about in art journals. Yaki Kornblit had plans to introduce graffiti to the European art market, to the same collectors who twenty years before had been drawn to Pop Art and had provided the enthusiasm and economic backing to launch that movement in the world, scooping most American collectors in the process. Yaki selected as his core group artists who not only were veterans of the subways, but who had also been included in important New York shows: Fashion Moda, the Mudd Club, the New York-New Wave show at P.S. 1, the Fun Gallery, and others. One by one, he launched Dondi, Crash, Ramellzee, Futura 2000, Zephyr, Quik, Pink, Blade, Seen, and Bil Blast in highly successful solo shows, and he organized a major breakthrough exhibit of works by these artists at the Museum Boymans-van Beuningen in Rotterdam.

Holland was fertile soil in which to plant these seeds. It had a lively, rebellious, and independent youth — provos, punks, and squatters who regularly staged confrontations with the police. The Dutch were already prolific street "taggers," and punk writers such as Dr. Rat and Dr. Air were "up" all over Amsterdam. Inevitably, some of these young people would

* While we acknowledge that *graffiti* is a plural noun in the original Italian and that correct grammatical English demands that it should be treated as such, since the advent of the phenomenon of graffiti-related art, the word in everyday speech has come to be commonly used as a singular. This vernacular usage, which is universal among practitioners of the art, now sounds better to those of us who are accustomed to it and we will continue the practice throughout the book. To those (including our own editor) for whom "graffiti" followed by "is" still sounds funny, we offer our apologies.

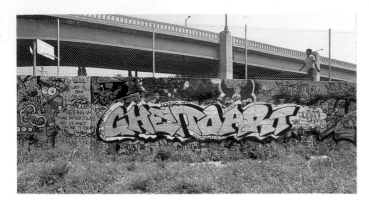

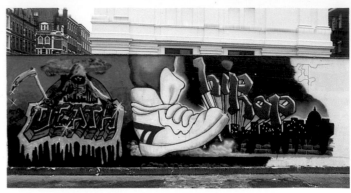

meet the great writers from New York at Yaki's openings, and this influence contributed to the rapid proliferation of spraycan art in Amsterdam and gave it a strong New York flavor.

Two trends have emerged since the art world embraced graffiti in the early eighties. In one, those writers who joined the establishment art scene began to respond to the influence of dealers, collectors, and other artists, and they discovered other motives to produce their art. They evolved as artists, their work becoming in some ways more complex, more subtle, and at the same time more appealing to collectors in the fast-moving art world. These artists have often lost sight of their original public, retaining only the use of the spraycan as a tool, vestige of a former vocation as graffiti bomber. The second trend is the extension of the original New York graffiti world beyond the subways that link the Bronx, Brooklyn, Queens, and Manhattan to the streets, playgrounds, and underpasses of Pittsburgh, San Francisco, London, and elsewhere. The young inhabitants of New York City who invented the art were part of a youth culture that included artists, break-dancers, rappers, and D.J.s and their creations were ways of communicating with one another. Likewise, it is young people who have taken up spraycan art wherever it has emerged in the rest of the world. The artists and their public are still mostly teenagers.

Probably the greatest agent for spreading this art form beyond inner-city America was the Hip Hop explosion of the early eighties. The films, videotapes, and books that described and promoted the culture of rap music, break- dancing, and graffiti writing made heroes of the young forerunners from New York's streets – Africa Bambaata, the Rock Steady Crew, Phase 2, Blade, Seen, Skeme, Dondi, and Lee to name only a few. Kase 2's formidable presence in the film *Style Wars* and the book *Subway Art* prompted writers in Pittsburgh and San Francisco to adopt his style and the camouflage technique he invented called "computer rock." In Spain, Bambaata is a demigod to young B-Boys who yearn to be "down" in his crew, Zulu Nation; while in London, Bristol, and Birmingham, England, they paint the walls with the Zulu symbol, the raised hand with extended index and little fingers, sign of love and peace.

In many cities, writers' first exposure to graffiti art was at a Hip Hop concert, often starring the Rock Steady Crew, one of whose members was Doze, a writer from New York. Others saw Malcolm McLaren's *Buffalo Gals* video, shot in front of *Sky's the Limit,* Bil Blast's handball court, or they saw the films *Wild Style* and *Style Wars*. Through these media, the culture of graffiti was transplanted intact, embracing language, history, customs, and rules, bombing, "racking," and the competitive spirit. *Beat Street,* a product of Hollywood, probably did more to spread

the word than anything else, even though the artwork in the film was done by professional scene painters, amateurs as graffiti artists without much experience with spraycans. But only New Yorkers, with a practiced eye, questioned the authenticity of the pieces that appeared on the screen.

The Statue of Liberty, the New York City skyline, bridges, and subway trains are the images commonly depicted in murals from Chicago and Los Angeles to Paris and Sydney. These are the icons that symbolize the wellspring of graffiti. The subway in particular arouses a response, even among kids who have never seen one. Spraycan art evolved on the side of a moving train. To be sure, it can easily be translated to a fixed surface, but it could never have started out there. In New York, writers have an almost mystical attachment to the trains, the giant worms, arteries in the belly of the beast. The drama unfolded on the trains, in the dark tunnels where writers encountered danger, high voltage, cold crushing steel wheels, giant hurtling monsters. The trains were the arena where the writer could prove himself, and it is this adventure that caught everyone's attention.

Throughout the history of New York subway graffiti, writers also did pieces on walls. They were a good place on which to practice and in periods when the "buff" was operating they presented a convenient alternative to the trains, a place to keep your name up. Graffiti in New York had first appeared on neighborhood walls when kids began tagging up their street names. Graffiti as an art form began to flourish when the writers, as they had come to be known, turned to the subways to take advantage of the high visibility, the huge potential audience, and the link with other like-minded kids throughout the city.

Other writers have stayed away from the trains and concentrated instead on painting murals in their own neighborhoods, refining their styles on walls and handball courts, sometimes invited by local merchants to paint riot gates. Still others were adept at both trains and walls. Lee was, at the same time, king of the city subways and a recognized master in his neighborhood. He carried the art of painting handball courts farther than anyone else before or since by comprehensively utilizing the given space. A different magic was at work here, that of a neighborhood transformed overnight by a mysterious hand. Suddenly to come upon a mural by Lee is like finding a treasure in a cave.

Trains have been painted in Vienna, Düsseldorf, Munich, Copenhagen, Paris, London, and Sydney, but they are rarely seen by anyone. This is because the writers in those cities are relatively few in number, and the transit workers can easily take the painted trains out of service and buff them. So, apart from a

Far left: Ghetto Art by Dream (Los Angeles), 1986
Left: Death and *Hip Hop* by Zaki (London), 1984
Below: Brim (London), 1985
Below center: Detail of piece by Children Are the Future, a US-Soviet collaboration (Yerevan, Armenia), 1985
Bottom right: Brim at Oxford, 1986

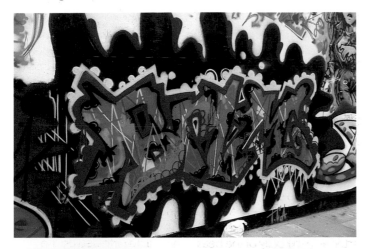

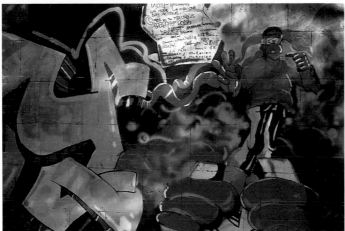

New York writers are proud of the history of the development of graffiti style, of the ordeals they have had to face to paint trains and of the harshness of inner-city life that each has had to come to terms with. Therefore, although they are flattered by the admiration, they view with a certain ambivalence their counterparts in other places, those youths impelled by their example to paint. They are pleased that what they have created is a source of inspiration to so many others, but they complain that these others have not paid their dues. Writers in California and Europe have been able to study and copy advanced styles that evolved in New York over a period of fifteen years.

One of the key figures in the development of New York graffiti art was Phase 2. He and a few of his contemporaries originated the forms and made the stylistic inventions that have defined spraycan art up to the present time. Phase is still an artist and his current work has passed beyond the narrow formal boundaries of traditional graffiti, while still retaining its fresh improvisational character. He has exhibited his work in Europe and has been able to observe at first hand the impact that the new art form has had on people outside New York. Phase is not surprised that others have been inspired by New York graffiti style and that they want to imitate and borrow from it. He told us:

When I went to Switzerland, they were checking out what I was doing and trying to enhance it and use it in their work. It's only normal, when you're into something and you see somebody doing it differently, you're either going to innovate, elaborate on it, or just take the thing and do it the same way. That's the difference between being creative and imaginative and just being there. But I think if you just had a bunch of guys that were developing all these new techniques, and there was nobody to go out and do the experiments, you would never have anything.

few forays into the yards, writers outside New York City have stuck for the most part to walls. Thus there is an essential difference between New York style and styles that have evolved elsewhere, a difference summed up by Shame 181 of London:

The Americans. I like their stuff but I wouldn't follow it. Their style is for the trains. Our style over here, I couldn't see any of that stuff being put on a train 'cause I don't think it would rock. For a wall, yes, alright. But to rock on a train, the piece needs movement. Most of the English pieces don't got no movement at all. It's like the piece is tearin' itself apart. When I see pieces on American trains, they just look like they're meant to be there, they just go with the train. Walls don't go anywhere, so for a wall, you could do anything.

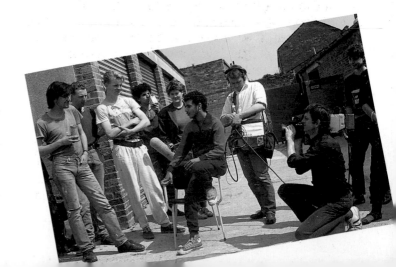

B-Boy by Shame (Manhattan), 1986

Writers in small towns around the world have had special problems not experienced by writers in New York, where by their enormous numbers they easily overwhelmed all law-enforcement and cleaning efforts for so long.

In Brühl, West Germany, there was a solitary artist named King Pin who had already begun to do pieces when he met Lee, who was visiting Kassel as an exhibitor in the Documenta show. This early enthusiast visited New York in 1983 and made his way to Henry's studio, the Graffiti Hall of Fame, Lee's walls on the Lower East Side, and the writers' bench at 149th Street in the Bronx — an alternative itinerary for particular tourists. Upon his return to Germany, King Pin sent pictures of pieces he had done in Brühl and occasionally he would ask to be sent things in return, like "fat caps," that are hard to find in Europe. In one letter he wrote:

I have been picked up and arrested by cops and, although they realized very well that I was King Pin, they let me only pay for the piece I did that night. Then they said to me, "Don't do it again, otherwise we will charge you for all the other things in town." That was definitely the end of my career as King Pin in our town. I believe that art has to be in the streets and, if it is necessary, against the law and not in a gallery or in the museum where nobody sees it and where it has an economic undertone.

Whether it's done on trains or walls, spraycan art is a form of public art. Writers everywhere concur in their desire to bypass the system and the normal channels for exhibiting art that are, more often than not, closed to them anyway. 3D of Bristol, one of the first writers in England, sees

the potential of the underground movement and people doing something for themselves instead of it being taken from the top. You know, you live in a city in which you really don't get any say at all. You could go and join some kind of committee and try and get things passed which might take years and it's all watered down. To actually go out and paint the streets to me is something still uncontrollable.

3D has been arrested several times, has had to pay fines and do penance in a weekend work program. Nevertheless, he is committed to this chosen form of self-expression. To the objection that writers are forcing their art on a public that has had no say in the matter, 3D answers that people are quite powerless in any case to do anything about the esthetics of their surroundings:

In the city you don't get any say in what they build. You get some architect that does crappy glass buildings or gray buildings. No one comes up and says, "We're building this, do you like it? Here's the drawings, we'll take a poll." So why should I have to explain what I do? I live in the city, I'm a citizen. Maybe in the eyes of this town I'm not so important, because I don't have all that high a status, as in class and job, but I live here so I should have as much say as anyone else, and that's why I go out and paint, 'cause I want to say something, and I don't want to be told when I can do it.

There are other writers who use different methods, while they share the same goal of getting their name and their art up in public. Depending on the approach that a particular city may take and its attitude toward graffiti, a writer may be able to play the system to his own advantage. Many cities have taken a constructive approach to what they see as a problem, finding ways and places for writers to paint, handing out grants for supplies, and creating a climate of cooperation with town councils and community businesses.

In Wolverhampton, an industrial town outside Birmingham, England, a politically astute young writer named Goldie realized early on that being the first in his community to "piece," he would be very vulnerable. As he put it, "I would be crushed!" In that way he saw that he would defeat his own purpose, which was to get his name up before the public and to ensure its survival. With the help of his agent, an associate from his days as a member of The B-Boys, a professional breaking crew, Goldie was able to get the support of the administration of his housing project to do pieces for the school and day-care center. He enlisted the efforts of several local businessmen to help further his plans. When we visited Goldie, his agent, Martin Jones, took us around to the local branch of the Pittsburgh Plate Glass Company, where lab technicians were helping Goldie by testing primer for canvas that would be both shiny and flexible in order to provide the optimum surface for spray paint. Next, we visited a paint contractor who invited Goldie to the factory to mix his own colors — a spraycan artist's dream.

Goldie says he owes much of his philosophy and his inspiration to Brim, a veteran writer from New York City whom the now defunct Greater London Council (GLC) had invited to England to lecture kids on the fine art of painting

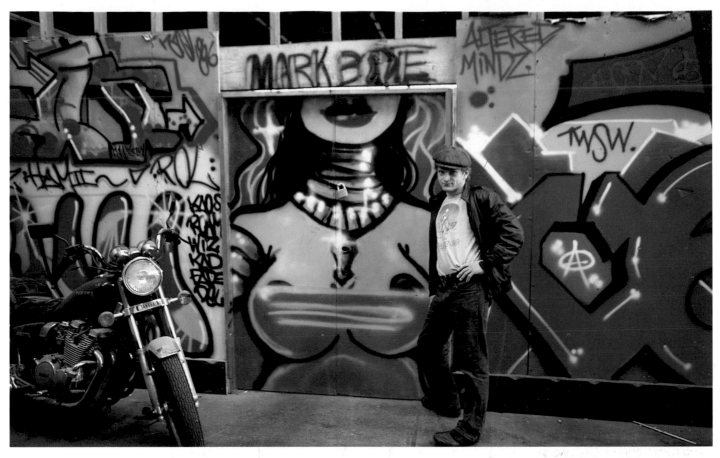

murals with an aerosol can. The two young men found that they had a lot in common, each one having grown up in the inner city on either side of the Atlantic.

It was because of the support of the GLC and other city councils that Goldie and London crews such as The Chrome Angelz and the IGA (Incredible Grove Artists) were able to devote themselves to painting legally. The GLC apparently saw in graffiti and Hip Hop a chance to strengthen its links with the community of disaffected young people.

At the Tabernacle Community Centre in London's Ladbroke Grove, Jenny, a youth worker, told how the GLC had given £2000 (about $3000) for the youth club to buy spray paint for the writers and track suits for the break-dancers. She explained that the kids at the center were all unemployed and living on social security payments of £23 (about $35) per week, and that they had all been in trouble and "inside" at least once: "If you haven't got the money, you either steal it or you can't do anything." We found the center bustling with activity and kids full of plans for painting murals and preparing for an up-coming break-dancing battle. Jenny said all this was in striking contrast to the prevailing mood in the days before Hip Hop. "I really haven't got the words to explain the sort of depression in the late seventies in the inner city. The first two years I worked here, absolutely nothing was happening ... pool, table tennis ... the apathy was really awful." Money from the GLC helped put some of the dreams the kids had within their reach. But not every community has confronted the graffiti in its midst with such equanimity.

In an effort to eradicate graffiti from its walls, the city of Philadelphia formed an anti-graffiti task force and promised writers amnesty if they would come out of the underground and give up bombing. As an incentive, the task force offered opportunities and commissions to writers to paint legal murals for the city, and at the same time it vowed to prosecute with severity those who persisted in their errant ways. Many writers decided to take advantage of the offer, and some have tended to play both sides of the fence, joining task-force mural projects by day and bombing the city with an alias by night. Meanwhile, the task force, in an excess of zeal, put pressure on local merchants to get rid of murals done in graffiti style on their shops, even though these had been painted with their permission.

The task force was apparently opposed not only to illegal graffiti, but to the graffiti style as well, and they forbade the use of graffiti lettering and B-Boy characters with their aggressive poses and expressions on task-force-sponsored murals, thereby engaging in a kind of ideological censorship. Parish, a Philadelphia writer, told us:

They want you to be like a robot, "We will tell you what to do." There's no way that's gonna work. Now if they had gone about it in a different way and let writers do murals, even controlled murals with Bodé characters and nudes and all that kind of crazy stuff ... but they won't let anybody do that. They just want you to paint their silly-looking murals with paint brushes, you know, like pictures of farms, grass land. ... No kid is gonna respect that. Writers are gonna go right over that.

Character by Sphere and Sketch (Los Angeles), 1986

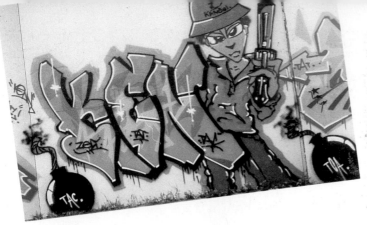

Ken, *B-Boy* by Shame
(Manhattan), 1985

Many parents in the United States disapprove when their children come home wearing B-Boy style clothes: Kangol hats, Kazal frames, name-belts, and wide-laced Pumas. They say it makes them look like hoodlums. The parents recognize that this style is symbolic of their children's allegiance to street rules and their assumption of a street persona. In the same way, the task force, which represents adult mainstream culture and civil authority, rejects graffiti-style lettering and fly-boy characters because they see in them an adherence to values that oppose their own. Parish continues:

Task force wouldn't like a name, B-Boy characters with hats to the side, sneaks and guns and all that kind of stuff, 'cause they think that kind of stuff makes us seem like a violent city ... like writers control the city. But the reason why writers draw those characters is to make you look "bad." You know, it's like an image of yourself and what you were thinking about that night ... it's like a statement to another writer. You're trying to talk to another writer without really meeting him. The way he sees your name, he sees characters, he can picture it in his head.

The task force say when they see characters, they feel violence. I don't understand that. I don't see anything violent about the way it's on there. I could see if you were drawing a bunch of people killing one another, but nobody draws anything like that. The B-Boy character projects the image for another writer. He's not trying to show that to the city.

Now that these artists share a worldwide network, messages, meanings, and symbols born in New York surge across state lines and national borders. If New York City generates style, it's because there is so much competition. With so many writers in town, you really have to be great to be noticed. And things move fast there because communication is so direct; you do a piece and millions of people see it right away. Unless writers start hitting 747s or transcontinental container trucks, they'll never re-create that intensity on a worldwide scale. But more and more, as contacts are made and photos circulate, they understand that their audience of peers is out there, beyond the neighborhood, far from the yards, tunnels, and elevated lay-ups.

At first, only the names of the New York kings were known to writers in the rest of the world, but gradually the flow of information is beginning to move both ways, and New Yorkers are becoming aware of writers in other places whose talent is making people sit up and take notice.

GLOSSARY

Bite To copy another writer's style.

Bomb Prolific painting or marking with ink.

Buff Any means employed by the authorities to remove graffiti from trains or walls.
To buff To erase.

Burn To beat the competition.

Cap, fat or *skinny* Interchangeable spraycan nozzles fitted to can to vary width of spray.

Chillin' Being out there and being cool.

Crew Loosely organized group of writers, also known as a *clique*.

Def Really good (derived from "death").

Down In, part of the group or action (e.g., "He's down with us").

Fade To blend colors.

Fresh Synonymous with *def*.

Generic Synonymous with *wak*.

Going over One writer covering another writer's name with his own.

Hit To tag up any surface with paint or ink.

Kill To hit or bomb excessively.

King The best with the most.

Nick Synonymous with *rack*.

Piece A painting, short for masterpiece.
To piece To paint graffiti.

Piece book A writer's sketchbook.

Rack To steal.

Rad The very best.

Stupid fresh Superlatively good.

Tag A writer's signature with marker or spray paint.

Tagging up Writing signature with marker or spray paint.

Throw-up A name painted quickly with one layer of spray paint and an outline.

Toy Inexperienced or incompetent writer.

Up Describes a writer whose work appears regularly.

Wak Substandard or incorrect (derived from "out of whack").

Wildstyle A complicated construction of interlocking letters.

Writer Practitioner of the art of graffiti.

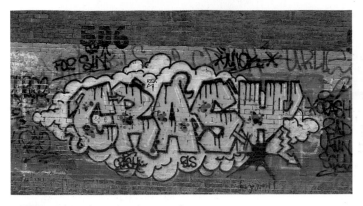

A n abandoned train tunnel runs beneath Riverside Park for its entire length. Freedom, a long-time local writer has made it his personal art gallery. He has painted pieces and poetry on the tunnel walls over a five-block stretch, taking advantage of overhead grates which let in the light. His latest piece, *The History of Graffiti*, pays tribute to the kings and queens of the train lines, whose names he has written in their own style on the trains above the lettering.

Above left: **Crash (The Bronx), 1978**
Above: **Cliff (Manhattan), 1976**
Below: Self-portrait **by Freedom, 1982**
Below left: **Freedom at the entrance to his gallery**
Bottom: ***The History of Graffiti* by Freedom, 1986. Tribute to Taki 183, Barbara 62, Voice of the Ghetto, StayHigh 149, Phase 2, Caine I, Cliff, Tracy 168, In, Blade, and Lee**

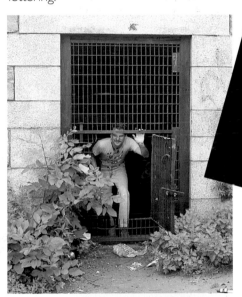

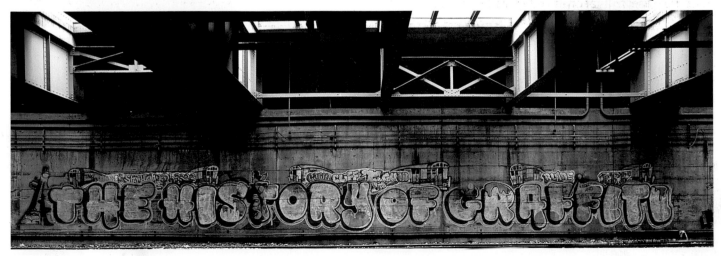

Lee

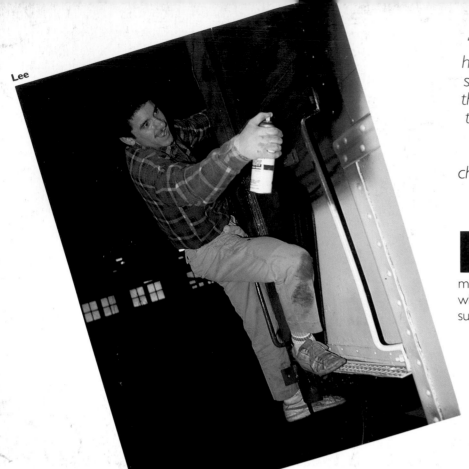

"Basically my life story is painted here. The lion is the protector. I've seen a lot deteriorate around me through the years — the bottom of the painting shows that — yet I've been able to move up in the art world. Most people don't get a chance to express themselves — it's like an adventure for me." LEE

Lee was the first train writer to see and exploit the full potential of handball courts for the creation of major works of art. Lee painted murals, while other writers used walls merely as surfaces on which to get their names up.

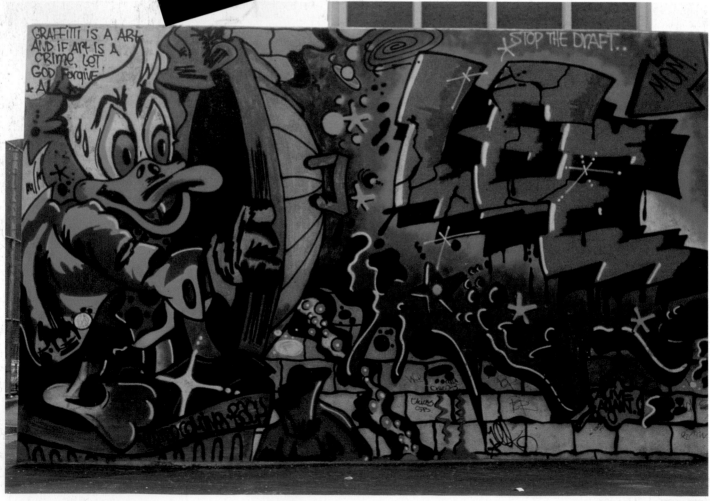

Lee, 1981

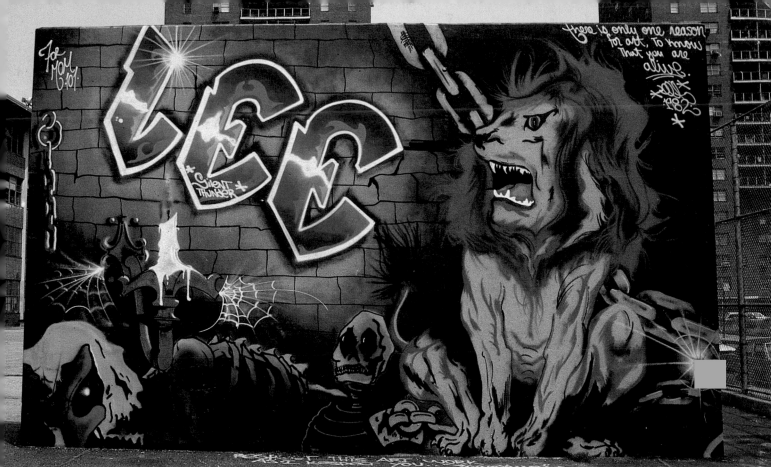

Lee, 1981

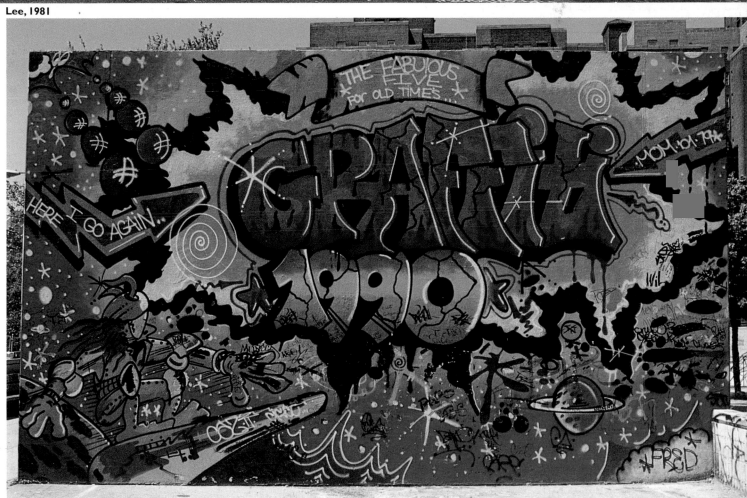

Graffiti 1990 by Lee, 1981

Here the trains run underground. Writers who live in Manhattan and get up on the trains have to travel to Brooklyn or the Bronx to see them, unlike those who live in the outer boroughs, for whom the trains are a constant presence and moving art show. This encouraged the development of wall writing and favored the talents of muralists like Lee, Bil Blast, Chico, Vulcan, and Jean 13.

Michael Stewart was tagging late one night on the Lower East Side when he was arrested. The next morning he was in a coma, and within two weeks he was dead, having sustained multiple injuries. Chico's wall (*right*) records this tragedy.

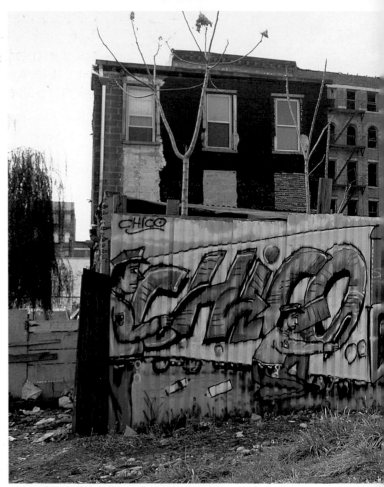

Tribute to Michael Stewart by Chico, 1985

Chico, 1985

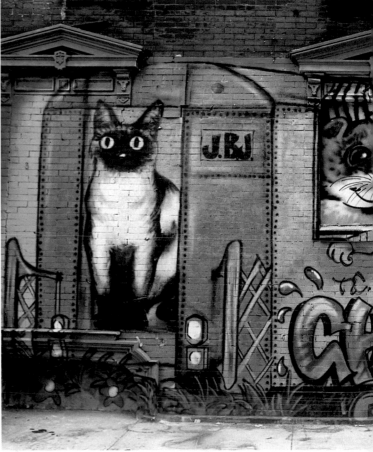

Chico, 1983

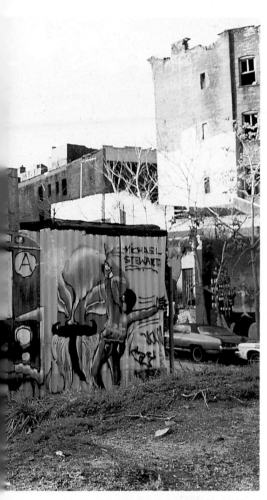

"People will never really understand what graffiti is unless they go to New York to live surrounded by abandoned buildings and cars that are burnt and stripped and the City comes out saying graffiti is terrible, but then you look around the neighborhood and you've got all this rubble and shit, and yet you come out of there with the attitude toward life that you can create something positive." BRIM

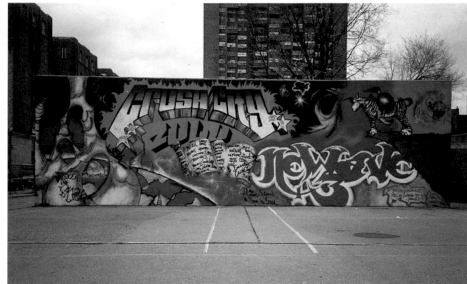

Crush City by Erni, Midg, and Size, 1983

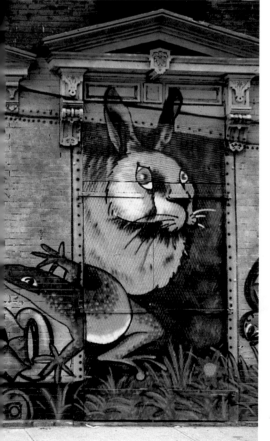

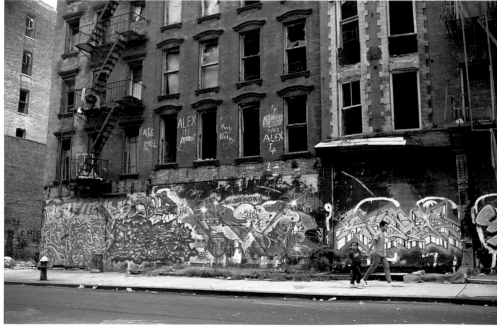

Sharp, Phase 2, Delta, Duster, 1985

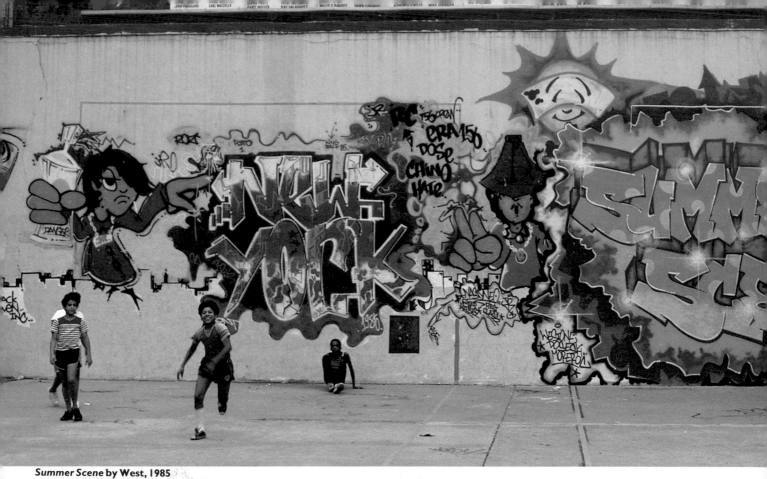

Summer Scene by West, 1985

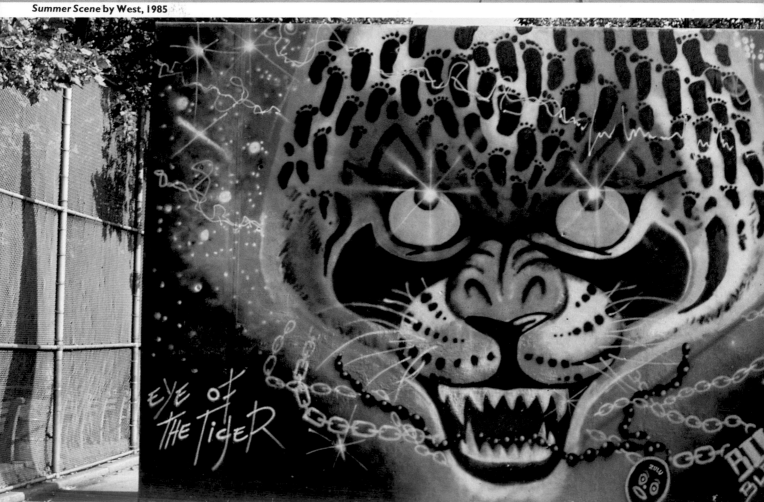

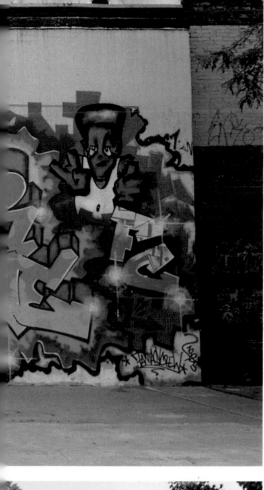

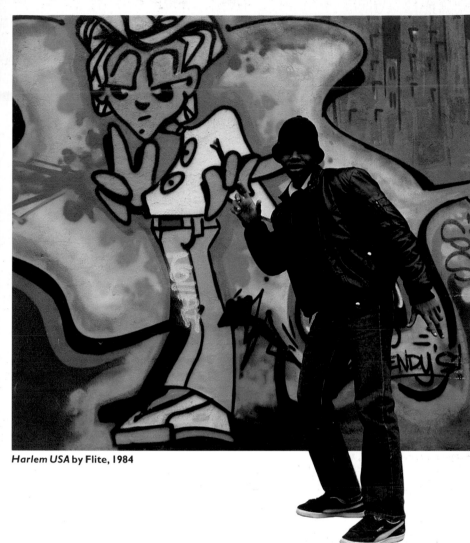

Harlem USA by Flite, 1984

Bil Blast made full use of this handball court (*left*) on Manhattan's West Side, with *Eye of the Tiger* on one side of the wall and *Sky's the Limit* (*overleaf*) on the other.

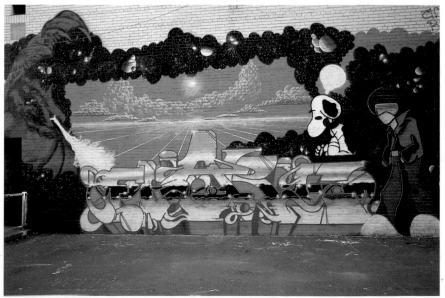

Eye of the Tiger by Bil Blast, 1982 *Flair* by Jean 13, 1985

"Sky's the Limit *was a message for the whole neighborhood. It stayed clean for a long time, but as it started to wear, first one tag and then a lot of others appeared. It hurts when someone goes over my piece, even tho' it was appreciated for over two years. That's why I painted over them 'Why can't some people respect art?'* " BIL BLAST

Sky's the Limit **by Bil Blast, 1982**

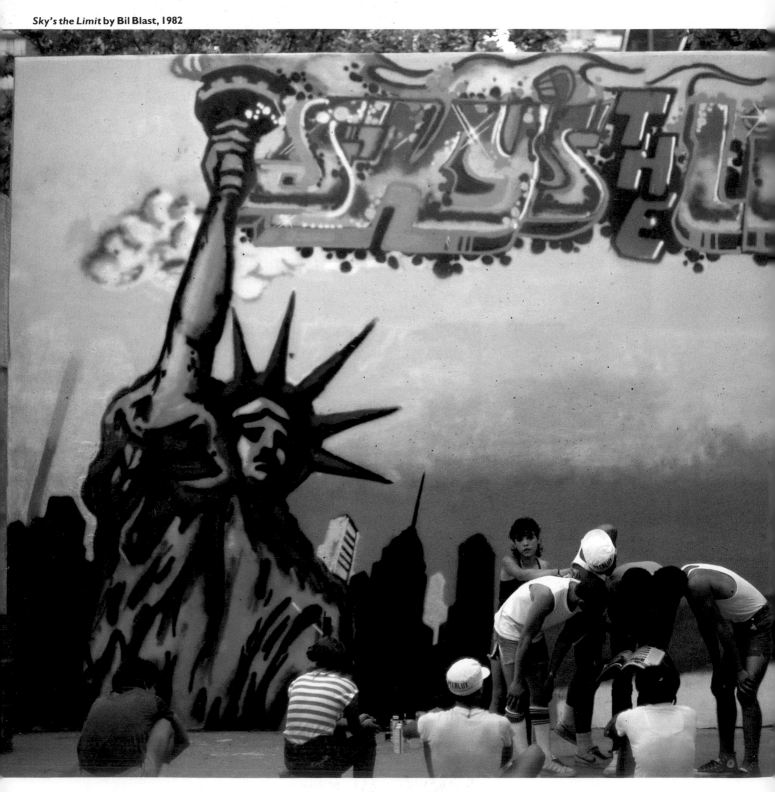

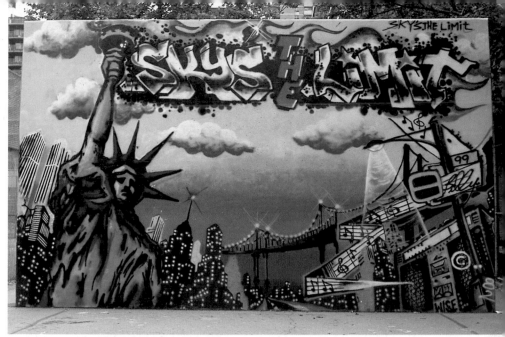

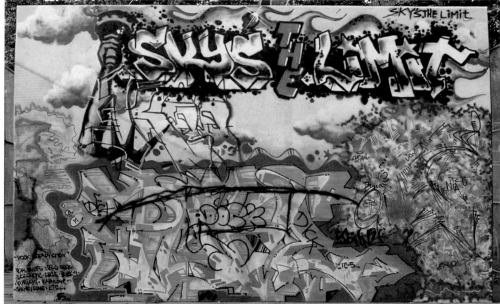

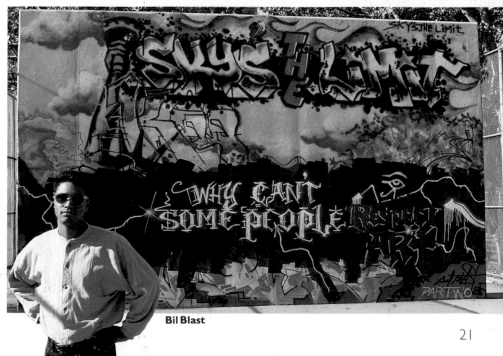

Bil Blast

21

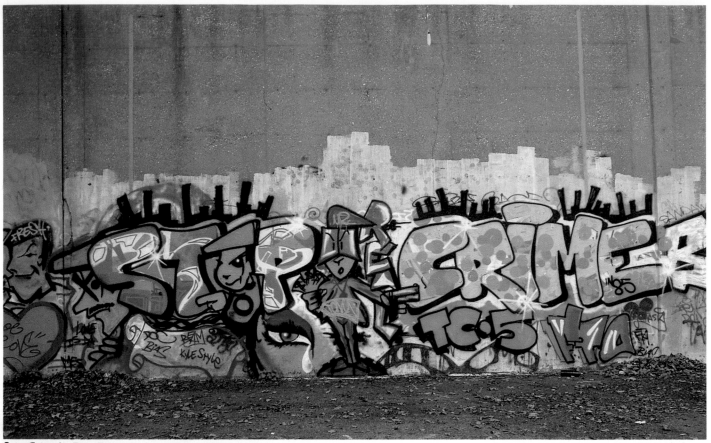

Stop Crime by Doc, Beam, Bias, and Kyle, 1985

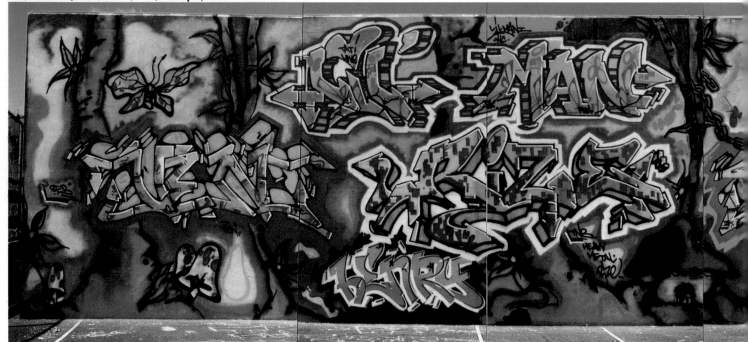

Lil Man, Rize, Ven, Rub, 1985

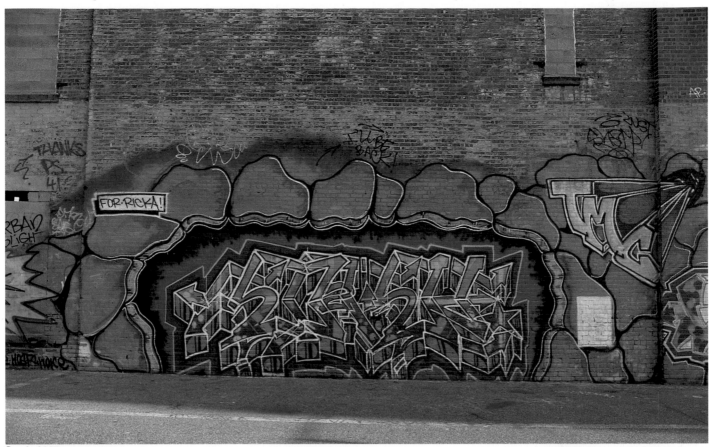

Stash, 1985

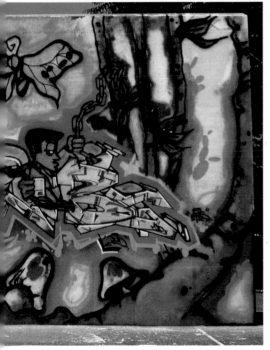

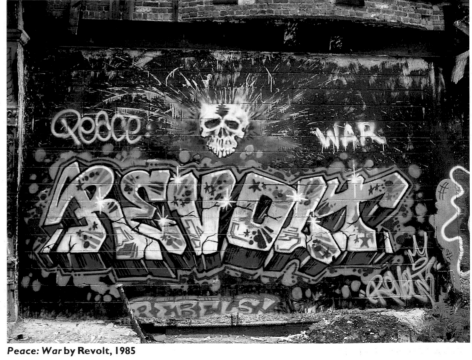

Peace: War by Revolt, 1985

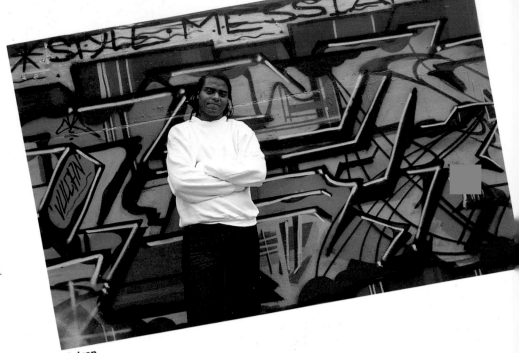

The walls of the Graffiti Hall of Fame at 106th Street and Park Avenue in New York City became an inspiration for youth across the country and around the world. Local "Halls of Fame" were designated in such far-flung places as Crocker Park in Daly City, California, a park tunnel in Amsterdam, Holland, and a demolished city block near the Stalingrad section of Paris, France. Although the languages of the countries may be different, they all say it in English: "The Hall of Fame."

Vulcan

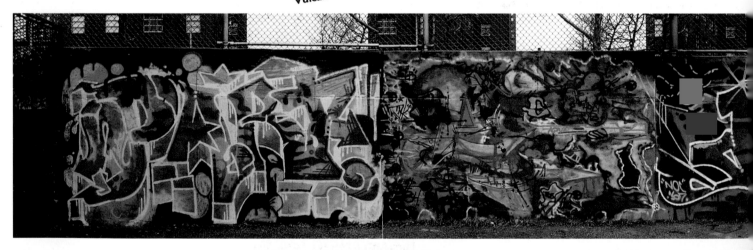

"The important thing about the Graffiti Hall of Fame is that it gave something to kids that they could relate to, some art form, more than going to galleries and museums. It gave thousands of kids a relation to art that they couldn't get in school or at home or anywhere else . . . and that's all over the world, not just in New York." VULCAN

Graffiti Hall of Fame **by Dez and Vulcan, 1981**

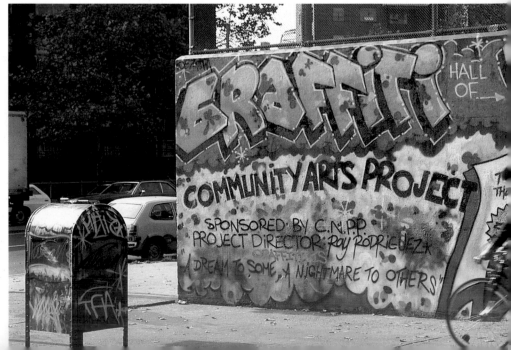

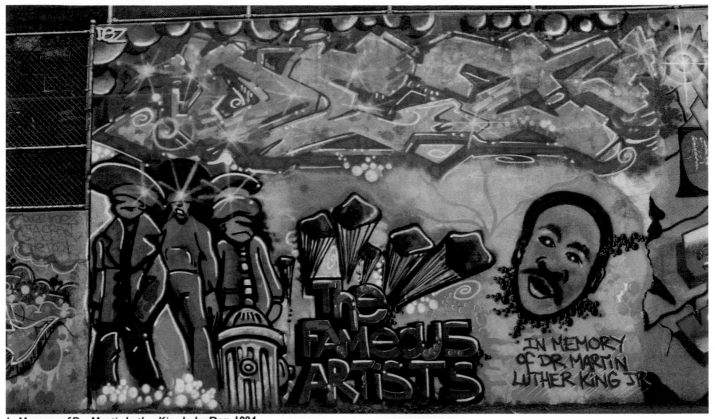

In Memory of Dr. Martin Luther King Jr. by Dez, 1984

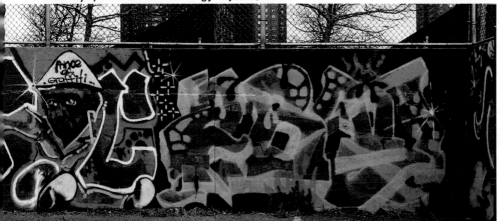

"*Fame, nowadays, is a lot different. You can get fame for having good style. Ten years ago, style was part of it, but you had to have a lot of good pieces, hundreds.*" VULCAN

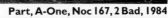

Part, A-One, Noc 167, 2 Bad, 1984

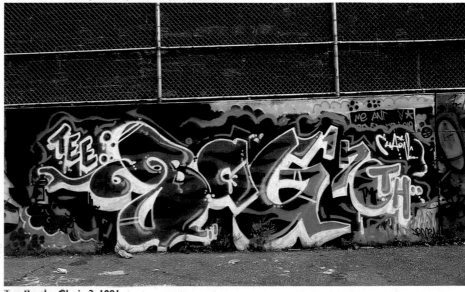

Tee Bag by Chain 3, 1981

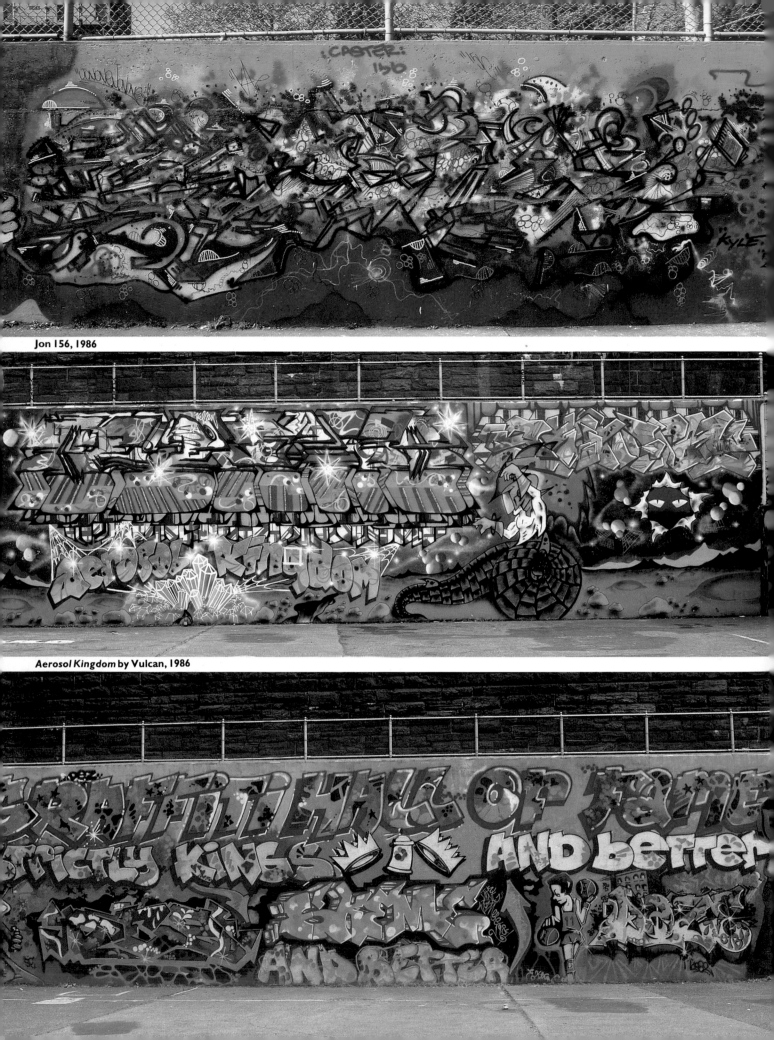

Jon 156, 1986

Aerosol Kingdom by Vulcan, 1986

"You ask someone, 'Do you like birds singing in the morning, do you think it's beautiful?' and the person will most probably answer, 'Yes.' And then you ask the person, 'Well, do you understand them?' and the person will go, 'Well, no.' And then you say, 'You don't have to understand something for it to be beautiful.'" BANDO

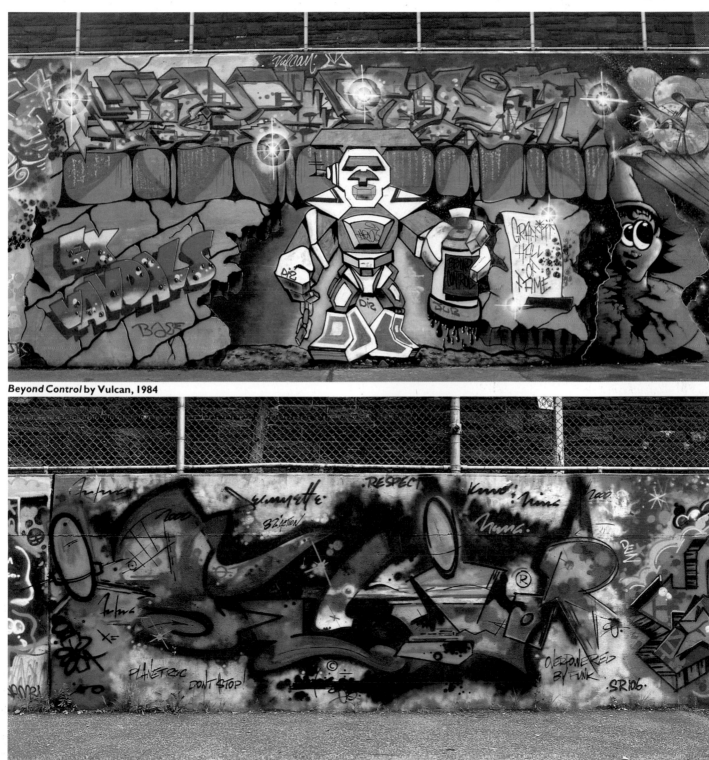

Beyond Control by Vulcan, 1984

Futura, 1982

Opposite: *Strictly Kings and Better by Skeme, Dez, and Daze, 1982*

"Sometimes, when doing a wildstyle, the letters won't be separated so you can see them individually – they'll be crunched together and one letter becoming part of another – the side of one letter becomes the side of the next letter. If you know about it, you can read it." SANE

The Bronx is the cradle of Hip Hop culture and graffiti on the trains has always been strong there. Four elevated train lines run through the Bronx neighborhoods, providing the residents with a constant exposure to the latest works of art and the young kids and future writers with the models of what they might one day achieve.

Most of the wall art in the Bronx reflects the subway art and consists of the writers' names. However, Fashion Moda, an alternative art space in the South Bronx, has provided the encouragement, and in some cases the funding, for a number of graffiti-style murals done by such writers as Crash, Daze, Noc, and A-One.

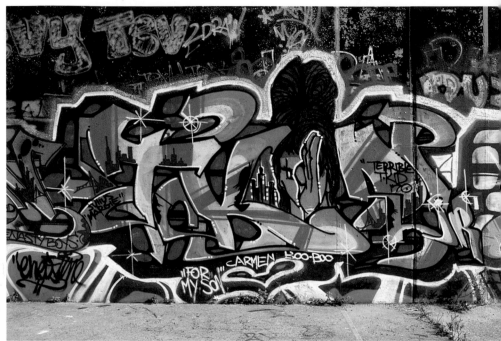

T-Kid 170, 1985

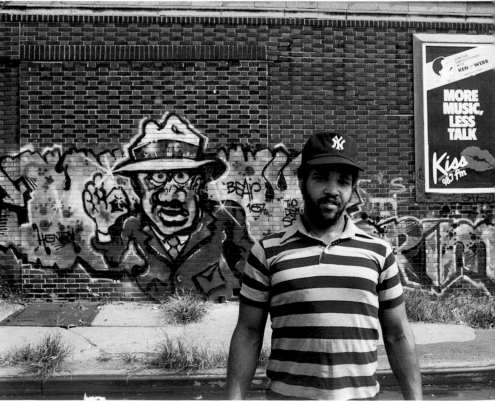

"Other writers – that's the only thing that matters. We want the public to like us, but other writers is what is important. We want recognition." SMITH

Bear 167, 1984

28

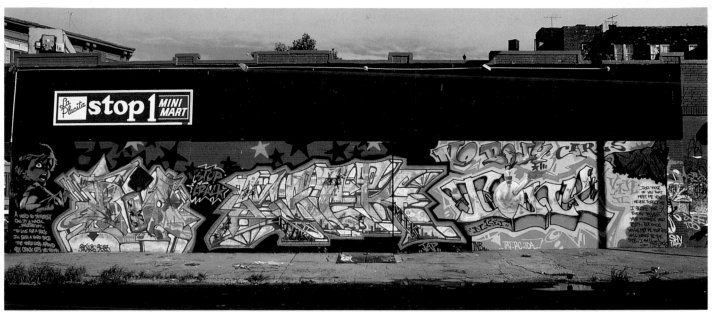

Bio, Mack, Tony by Bio, Mack, and Nicer, 1986

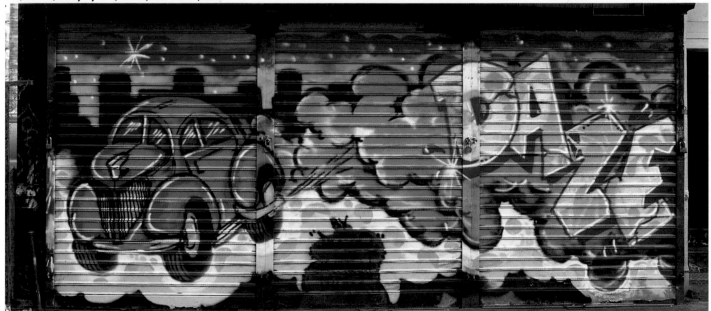

Daze, 1981

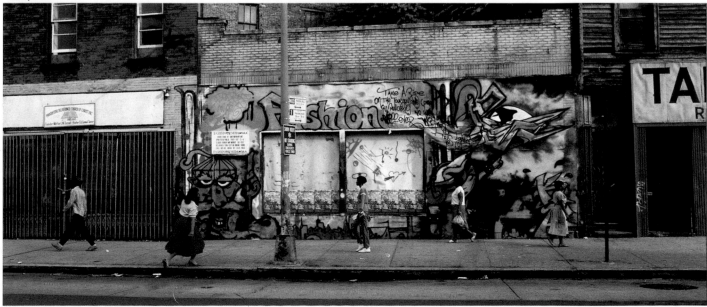

Fashion Moda by Moet and Delta, 1986

29

"We're out here every Sunday morning during the warm weather months, and we try to maintain at least one wall to play on. We appreciate this art, but it's difficult to follow the flight of the ball when you got a lot of colors to contend with. If you don't play handball, you don't really experience the frustration we have when we come by here and see this on the walls. I could appreciate it if it didn't interfere with what we're doing." HANDBALL PLAYER

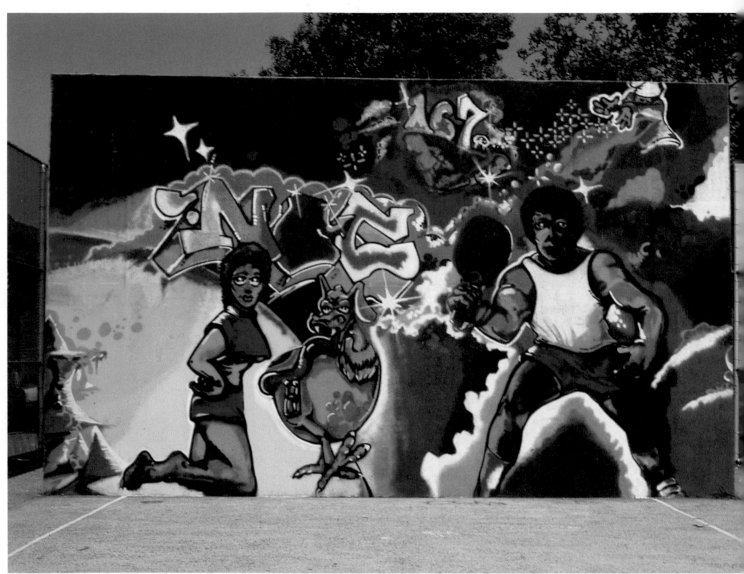

Noc 167, 1983

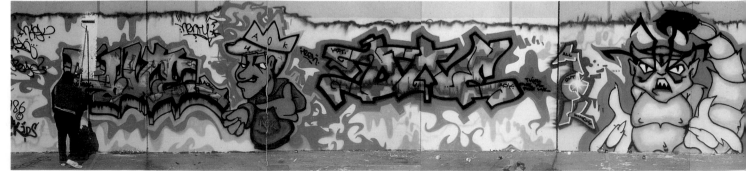

Barnsley College

Tracy 168 with members of the Wild Style crew

"Wildstyle is people. It ain't even art. It has a lot to do with how you act and who you are. You gotta be good at what you're doing. The best writers were from the crew Wild Style." TRACY 168

Conflict often arises between spraycan artists and handball players, who prefer to preserve the ball courts for the game for which they were originally intended.

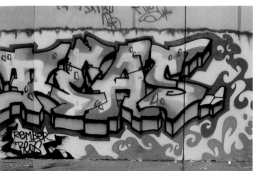

Live, One, Reas by Hask, Mesh, and Reas, 1986 Tracy 168, 1984

"Seen — the ultimate graffiti writer. He's done everything. He's done it all the right way. It's pretty much flawless. There is not much better you can get." SANE

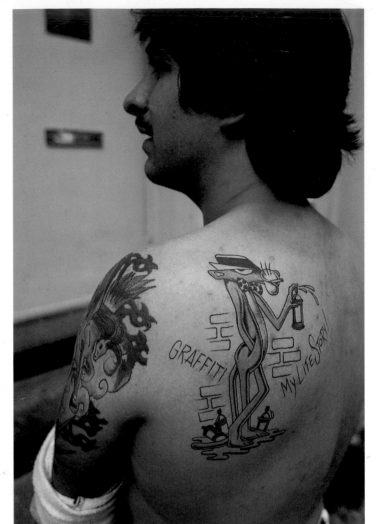

Seen's influence on style in New York City is quickly apparent to anyone who visits his East Bronx neighborhood. In other parts of the United States and throughout the world, he is probably one of the most imitated and emulated of New York writers.

Seen

"Graffiti is for kids. I think if you're over twenty you should give that shit up. The sad part about it is, by the time you become twenty is when you get good." TRACY 168

Madseen wannabees

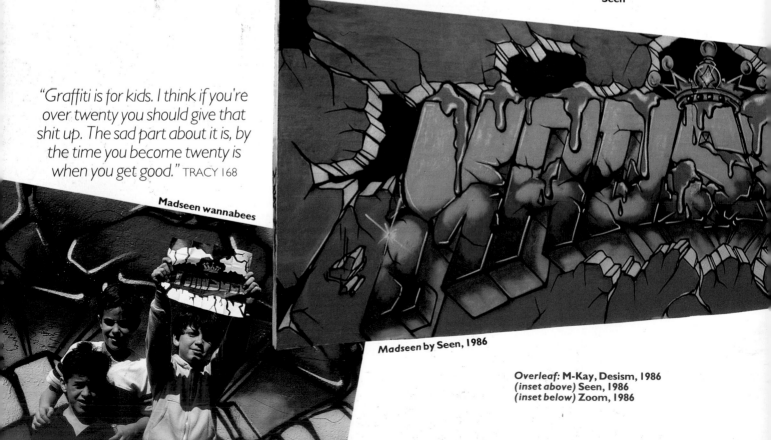

Madseen by Seen, 1986

Overleaf: **M-Kay, Desism, 1986**
(inset above) Seen, 1986
(inset below) Zoom, 1986

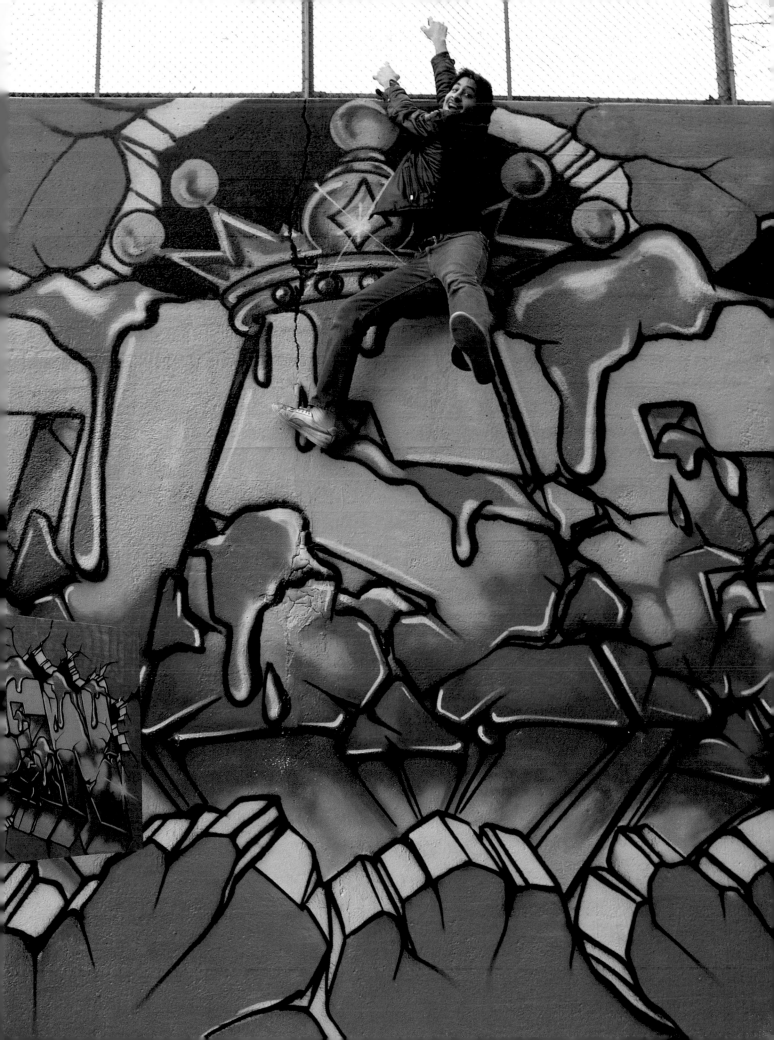

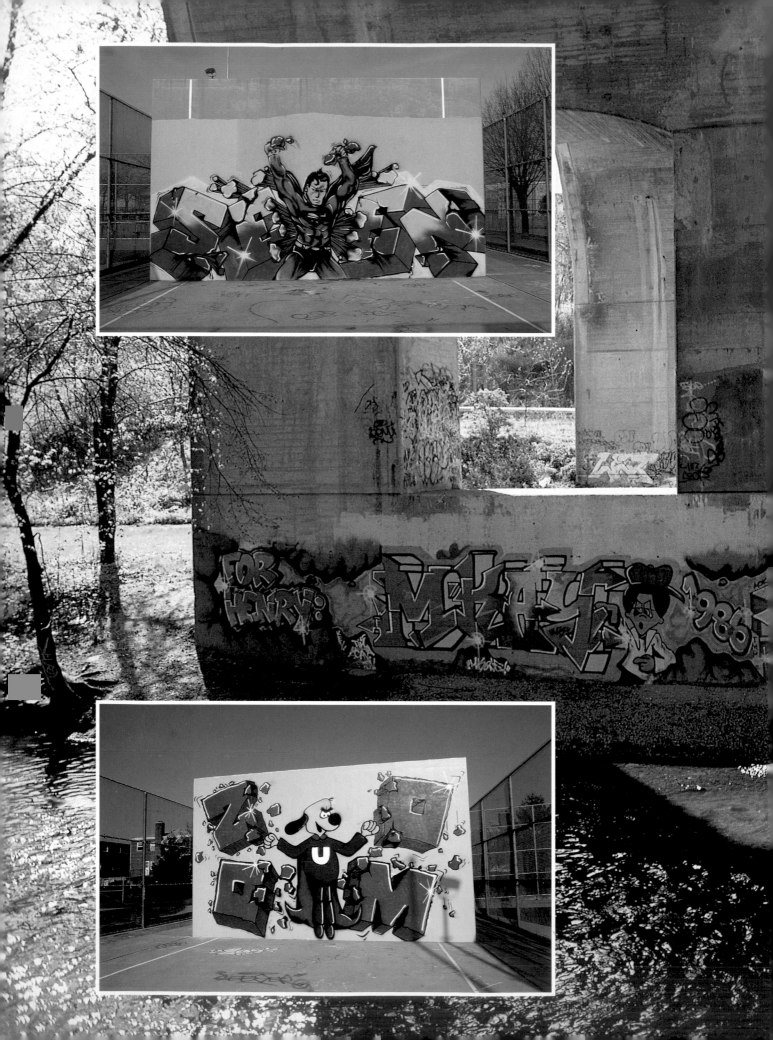

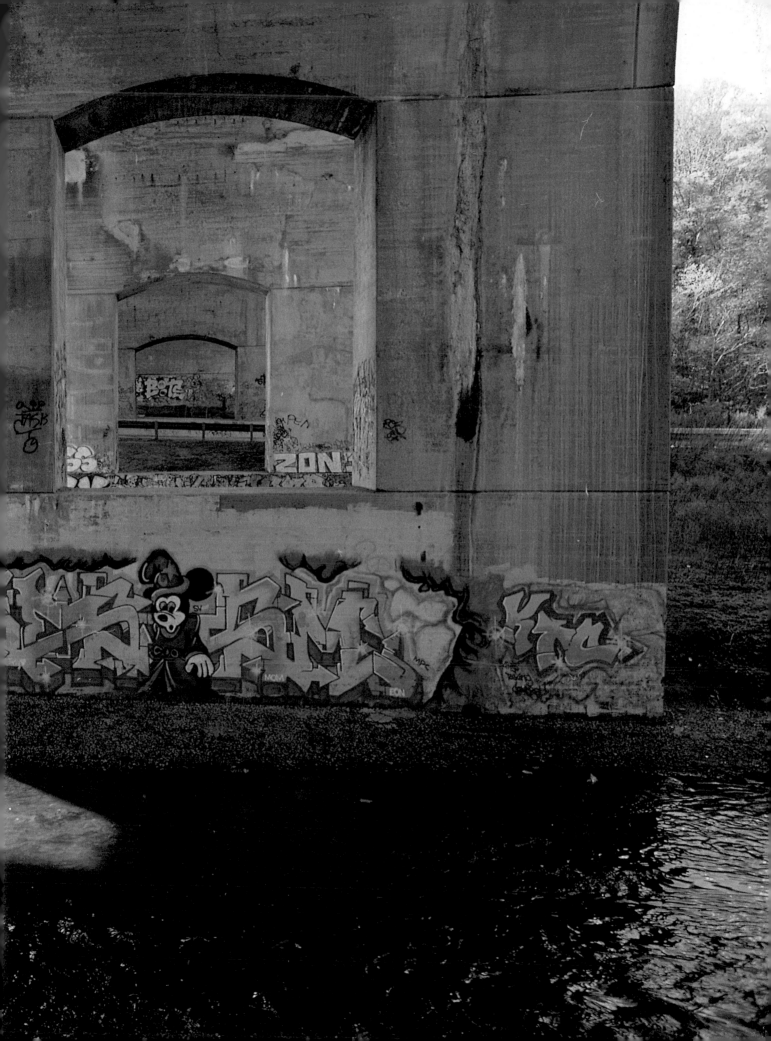

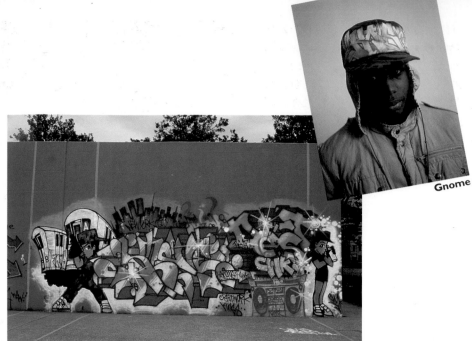

Gnome

It is not only in widely scattered cities around the world that local styles have evolved in spraycan art. Even within New York City, an identifiable Brooklyn Style has emerged that is recognizably different from that of Manhattan and the Bronx.

Gnome, Dest, 1985

36

"The arrows go straight up and down — FBA arrows come off the side of the piece. Brooklyn Style arrows either go straight up and down or straight to the side and Brooklyn Style letters got more curves — Gnome basically made it up." DEAN

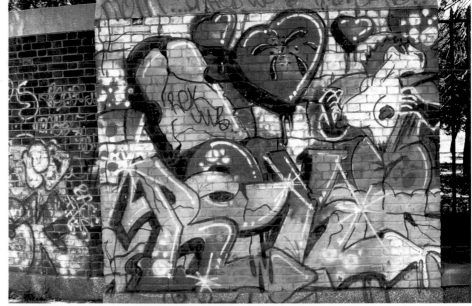

Rek, 1983

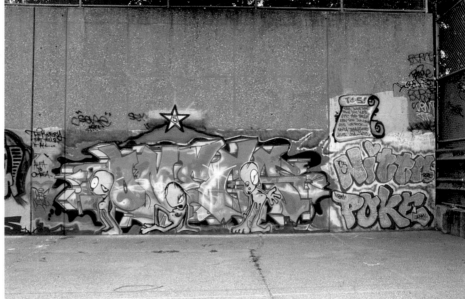

Omega **by Doze, 1985**

***Rockin in the 3rd Dimension* by Revlon, 1985**

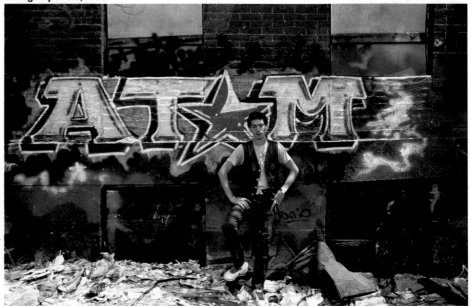

Atom, 1984

The competitive spirit among spraycan writers ensures that, whenever two or more of them go piecing together, they will battle one another.

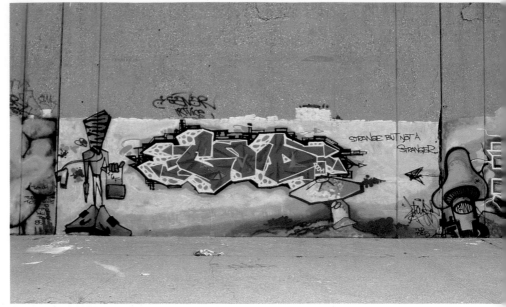

God by Staff, 1985

"That was a battle vs. Doc . . . the God vs. Arab. Doc was supposedly destroying himself with that piece because all the arrows pointed inward. He was saying that at ground zero everything is destroyed, obliterated." STAFF

"This is definite Battle Style. This piece is so armed for warfare it's ridiculous. This was a kamikaze run, and the sole purpose of this piece was to destroy all the other pieces next to it and itself." DOC

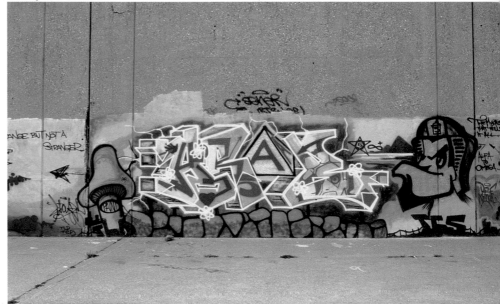

Arab by Doc, 1985

"This lady came up to me and said, 'Who did this wall?' I said, 'I did.' She goes, 'Oh no, you couldn't have done this, you're not black.' She said I was brainwashed, that the wall's all violence. She said I should cleanse my soul, that I was gonna brainwash all little kids to think that our world is all violence. She thinks Bay Ridge doesn't have no violence, that it's like some beautiful land, heaven, or something. If she would read the newspaper, she would wake up. She wants us to think we're in Disney World or something." KAVES

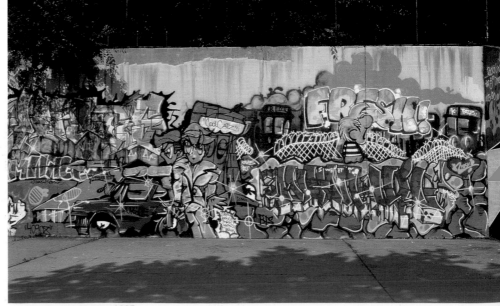

Miami Vice by Kaves, 1985

S taten Island is New York City's only
borough without a subway. The
Staten Island Rapid Transit, a surface
railway, is by all accounts heavily guarded.
Walls and handball courts present the
only opportunity to get up.

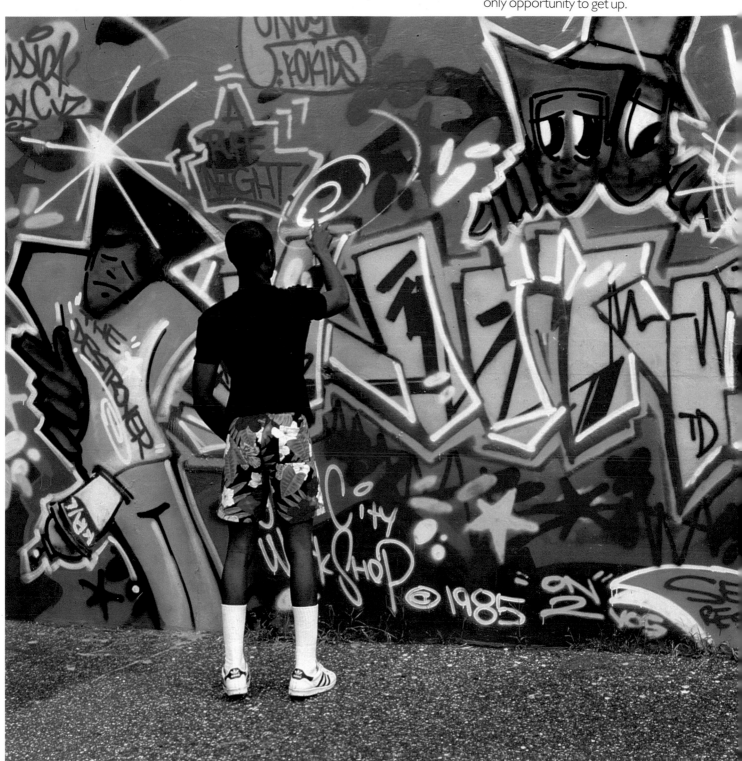

Wine by Lask, 1985

Queens is more suburban than the neighboring boroughs, but in spite of its peripheral position, it has a vital graffiti culture focused around school-yards and parks, where handball courts offer ideal surfaces to paint on.

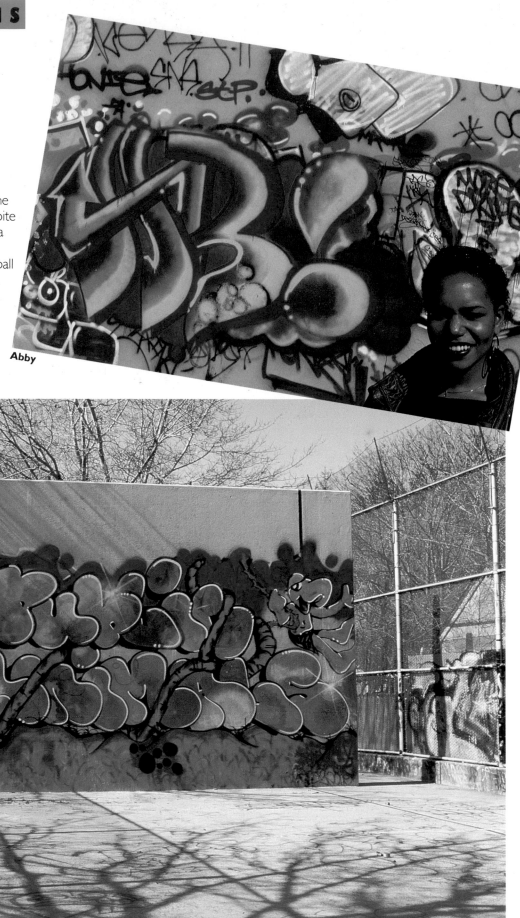

Abby

The Public Animals, 1985

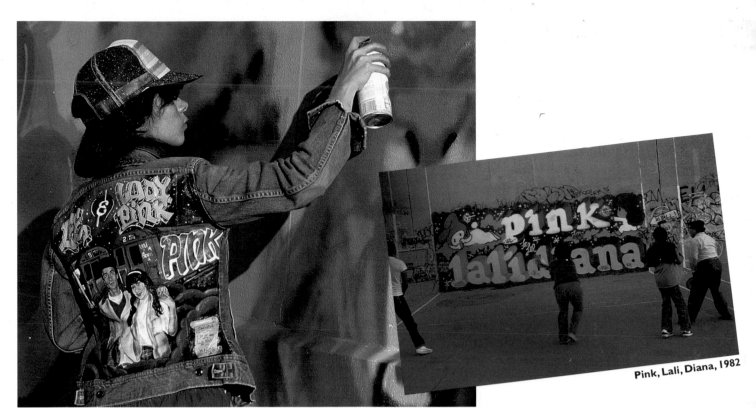

Lady Pink

Pink, Lali, Diana, 1982

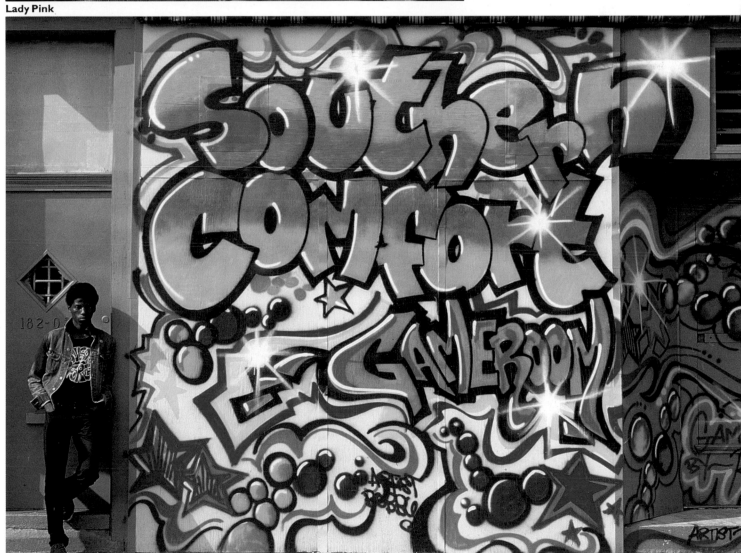

Southern Comfort Game Room by Cey, 1982

41

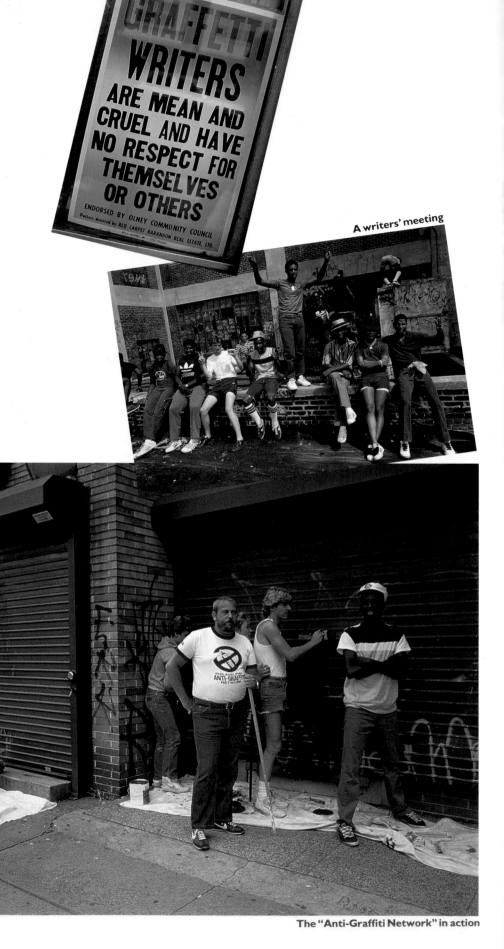

GRAFFITI
WRITERS
ARE MEAN AND
CRUEL AND HAVE
NO RESPECT FOR
THEMSELVES
OR OTHERS

ENDORSED BY OLNEY COMMUNITY COUNCIL

Posters donated by RED CARPET BARANDON REAL ESTATE, LTD.

A writers' meeting

Tagging appeared in Philadelphia even before it did in New York. Cornbread was getting up there in the sixties. At least one Philadelphian, Top Cat, was an important influence in New York. Top Cat moved to that city and brought with him the tall, skinny lettering that became known as Broadway Style. But, for the most part, the current has gone in the other direction and Philadelphia has followed her more intense neighbor in the evolution of style.

One of the Mayor's top priorities is to wipe out graffiti in the course of his administration. He formed the "Anti-Graffiti Network" task force to carry out the job.

The "Anti-Graffiti Network" in action

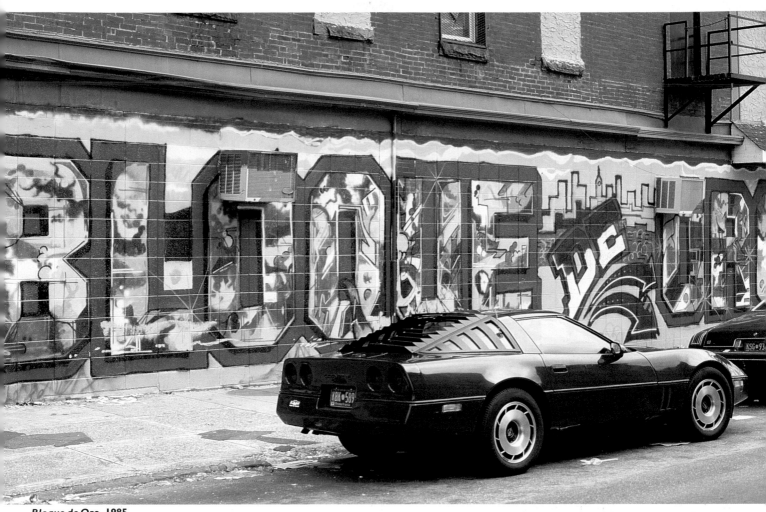

Bloque de Oro, 1985

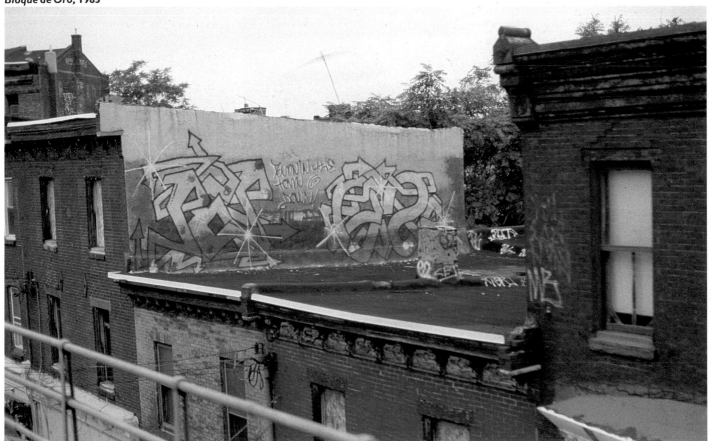

Pep, EZ, 1985

43

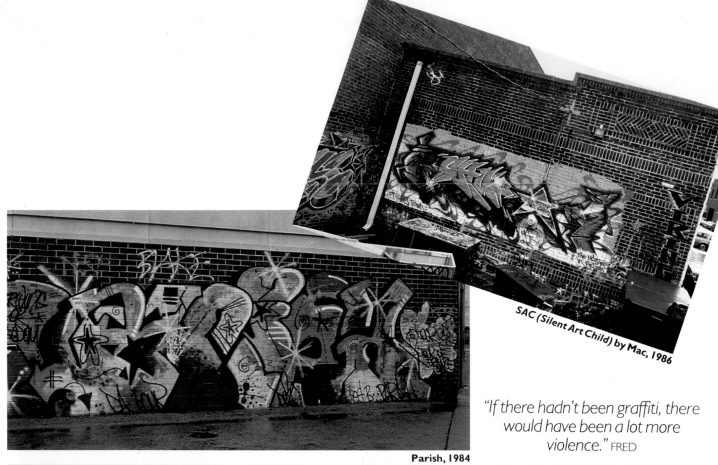

SAC (Silent Art Child) by Mac, 1986

Parish, 1984

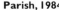

"If there hadn't been graffiti, there would have been a lot more violence." FRED

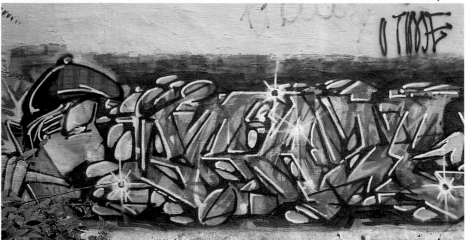

Braze, 1986

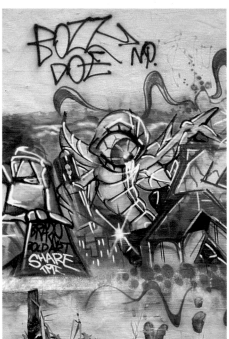

Share, 1986

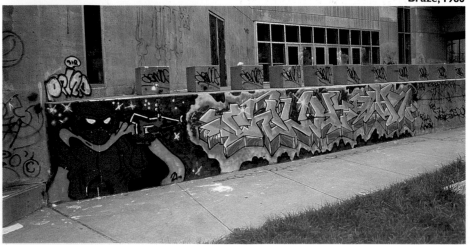

Philly Wars by Espo, 1985

In smaller American cities like Pittsburgh and Cleveland, the development of style was limited by the fact that it was easier for the authorities to single out the few known writers and hold them responsible for anything painted on the walls and public transit. Writers need other writers to compete with and to communicate with, for comparison, reflection, and a sense of common purpose. It's as if in any community a critical mass of writers has to be reached for graffiti culture to form. In Pittsburgh, one writer told us that the advancing gentrification of his neighborhood had destroyed the budding graffiti culture.

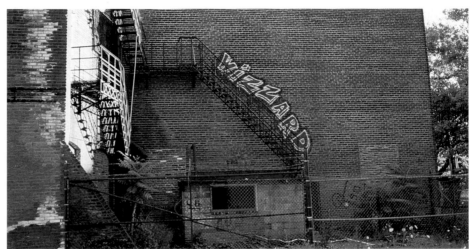

Wizzard (Cleveland), 1985

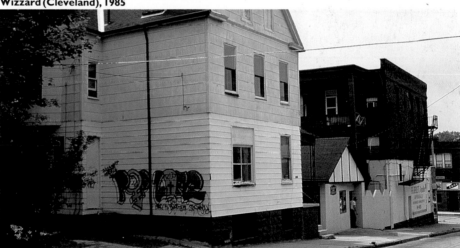

Pop Life by Dasez and Smash (Pittsburgh), 1984

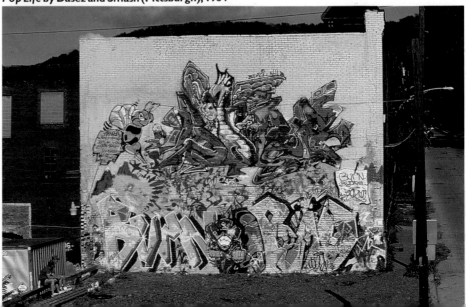

Buda, Bad, Burn (Pittsburgh), 1986

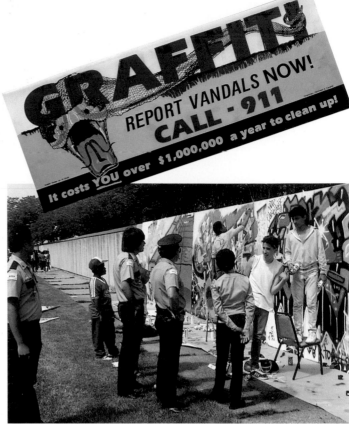

Chicago's writers tend to concentrate their efforts on rooftops and along the elevated train lines. From time to time there has been public sponsorship of spraycan art and private commissions. Public signs in transport and on benches indicate the level of city efforts to control the proliferation of non-permission pieces and extensive tagging.

Chicago by **Trixter**, 1985

A public art project, 1985

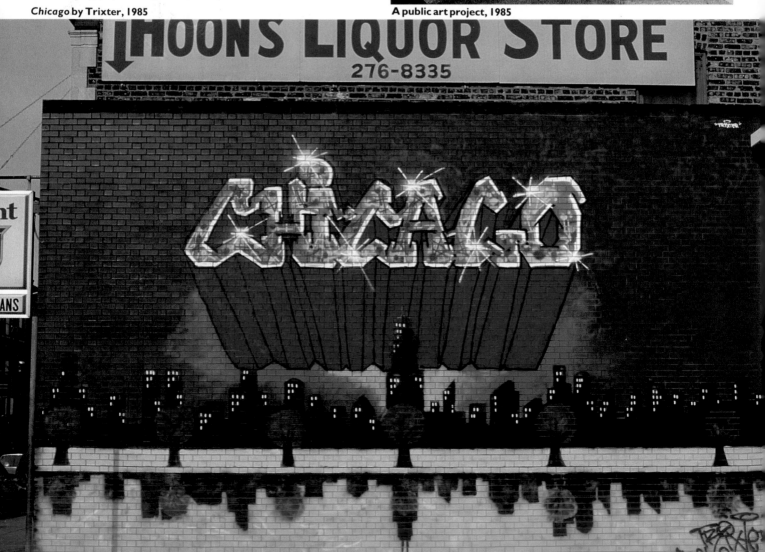

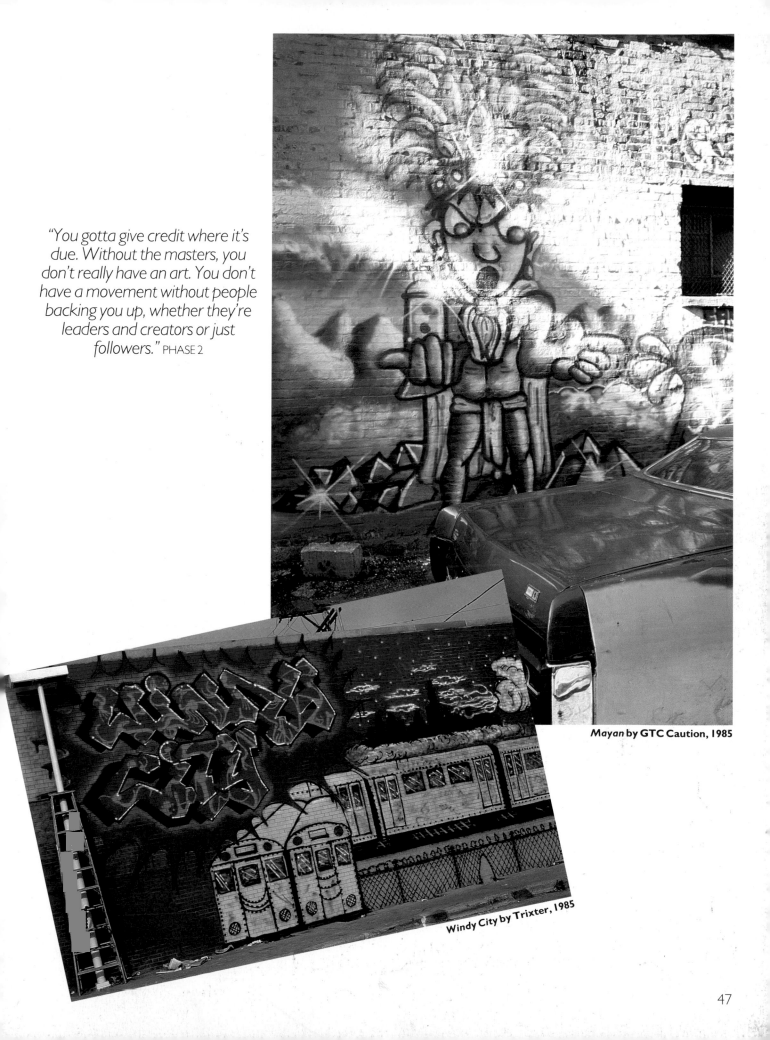

"You gotta give credit where it's due. Without the masters, you don't really have an art. You don't have a movement without people backing you up, whether they're leaders and creators or just followers." PHASE 2

Mayan by GTC Caution, 1985

Windy City by Trixter, 1985

Although late to respond to the media exposure of spraycan art, writers in San Francisco and the East Bay cities of Berkeley and Oakland developed quickly. Coming from diverse economic backgrounds, they are more strongly committed to crews than are their counterparts in Los Angeles. An early impromptu slide show planned for an audience of thirty or so drew two hundred and twenty writers and taggers. The San Francisco writers have concentrated on school-yard walls and have made Crocker Park in Daly City their Hall of Fame. In Oakland, they write along the rail lines and Berkeley writers for the most part make their mark on school-yard walls. As in other U.S. cities, extensive tagging in addition to piecing motivated the establishment in San Francisco of a "Mayor's Anti-Graffiti Task Force", and public bus signs encourage citizens to become informers.

Crayone

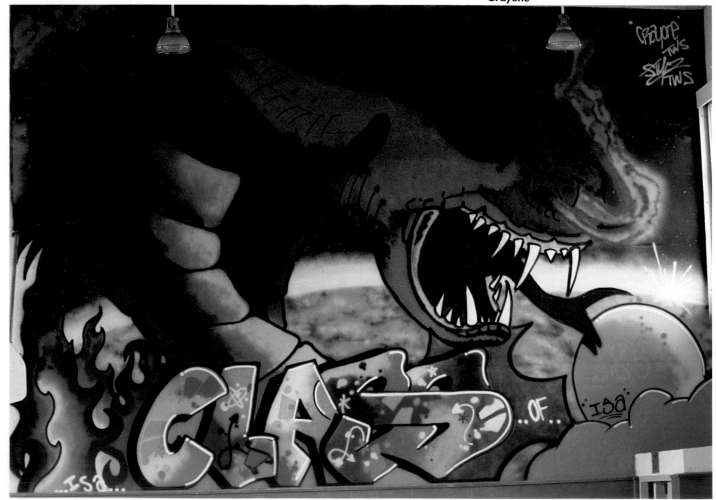

***Cobra* by Crayone and Guess, 1985**

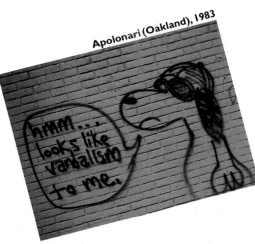

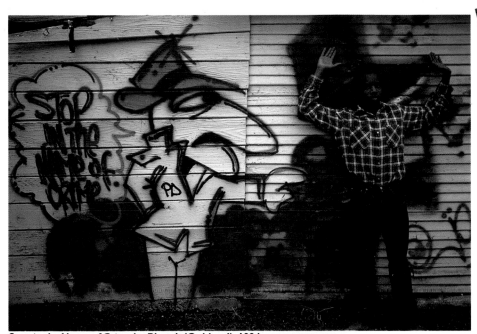

Stop in the Name of Crime by **Phresh (Oakland), 1984**

"You get two kinds of recognition. You're criminals, you're vandals, you dirty up the place. That's one kind of recognition from the older generation. Then you've got the younger generation like, 'Wow, you're good. . . . You're a guy with talent.'" ERIC

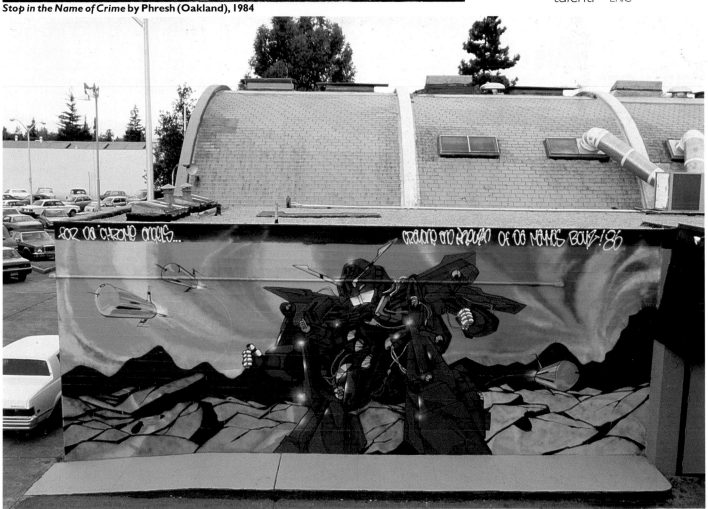

Total Destruction by **Crayone, Raevyn, and Man 45 (Palo Alto), 1986**

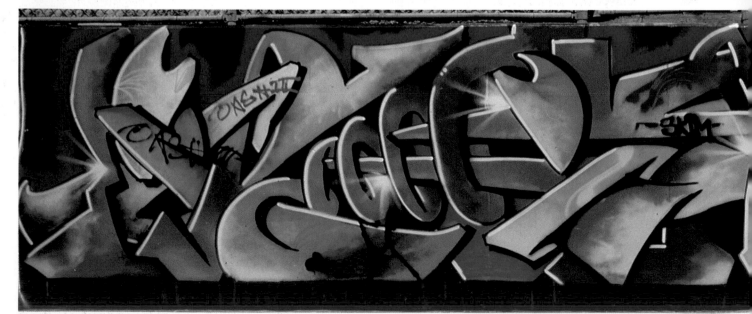

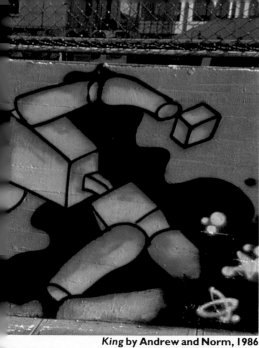

King by Andrew and Norm, 1986

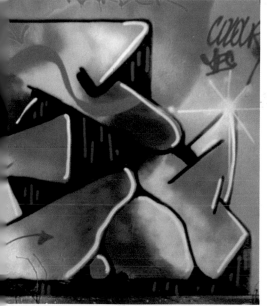

Noe by Colour and Robs, 1986

Raevyn, 1986

"New York style is either 'wildstyle,' 'computer,' or 'smooth.' Kase brought out 'computer rock,' Crayone brought out 'slice and shift.' San Francisco matches colors differently. Out here it's called 'abstract' — a whole bunch of little bits and arrows inside. New York has it but it's outside. Background counts a lot out here." ROBS

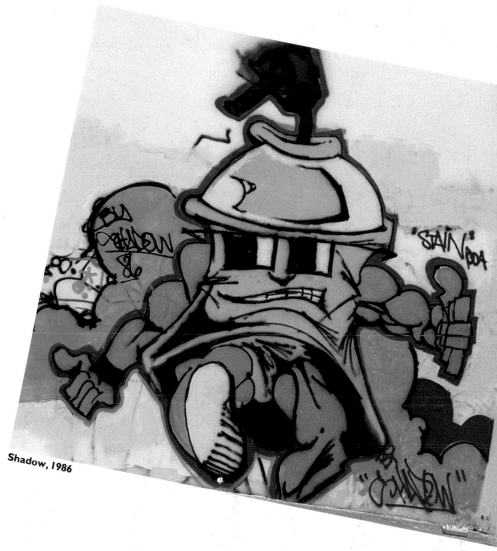

Shadow, 1986

Overleaf: Tone, Now, Rob by **Tone, Colour, and Robs,** 1986

51

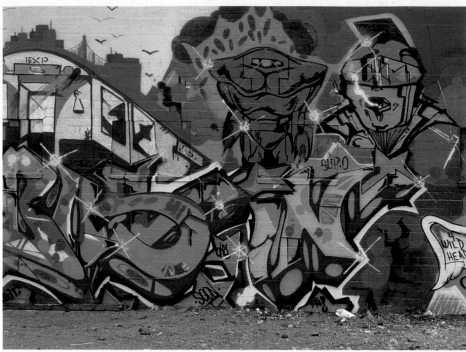

Los Angeles had a long history of early gang tagging. The distinctive "cholo" letters were, and still are, visible in many parts of the city. It wasn't until the eighties that writers coming from the east coast brought New York style, and this, along with the media exposure, inspired a small group to try their hand at spraycan art. Pieces were generally limited to very specific isolated sites such as Venice Beach, the Beverly Street pit, the Pan Pacific Building before it was torn down, and the Jefferson Street enclosure. Writers would gather at Radio-Tron to exchange information, but communication was limited due to the widely scattered layout of the city.

Bos In by Soon, 1985

Opposite: Myshka by Cooz and Risky, 1985

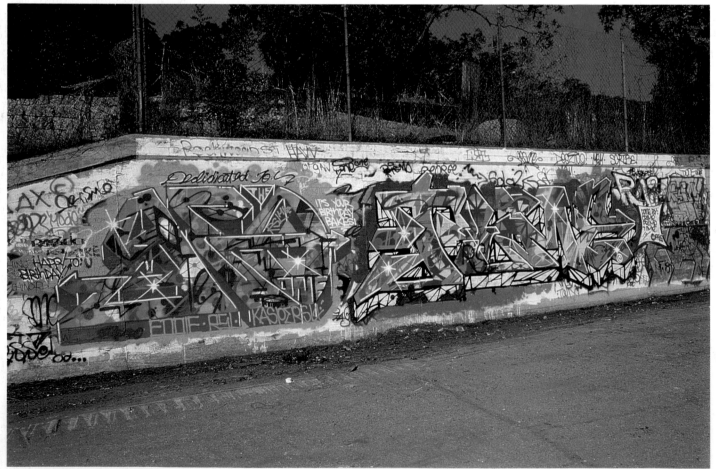

Geo, Rick, 1985

Opposite: Delo, Riot 68, and Sane, 1986

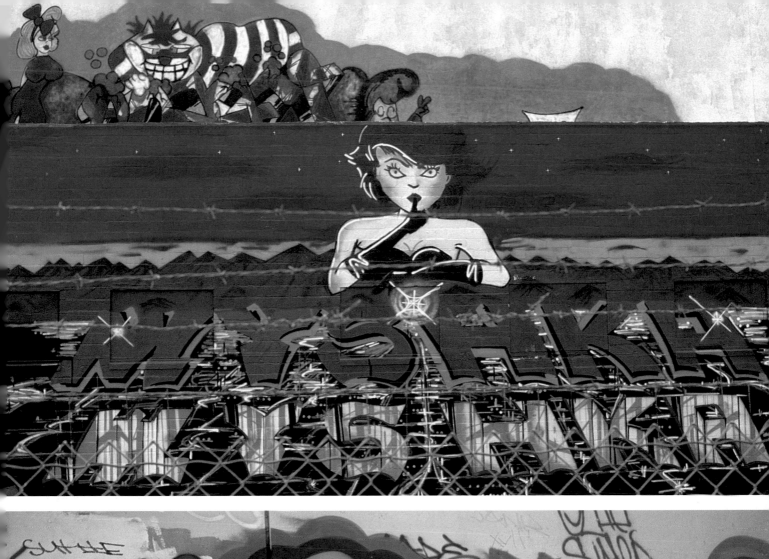
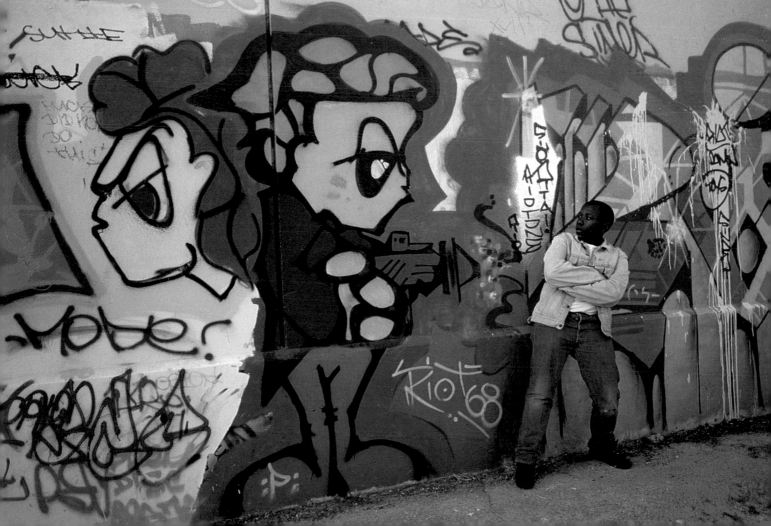

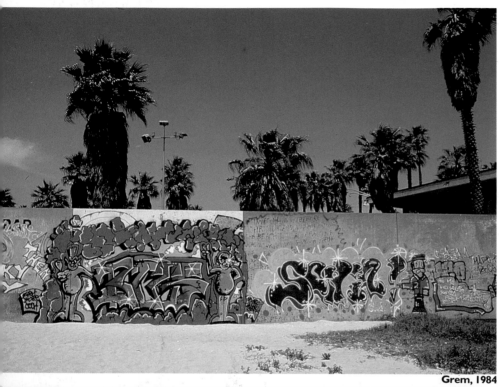

Grem, 1984

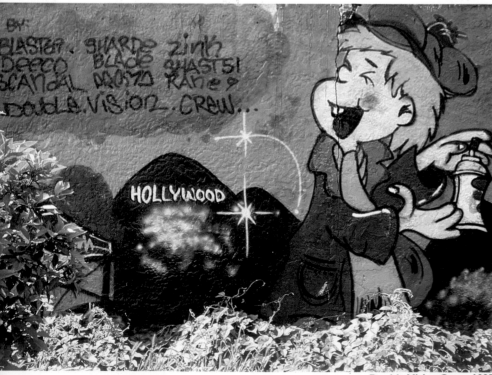

Double Vision Crew, 1985

"The first night we couldn't find the mountain. The second night there were people playing flashlight. The third night — I wasn't leaving until I did it. While I was doing the second 'E', out of nowhere huge klieg lights lit up the sign and a helicopter flew over. We hid for almost two hours." SEEN

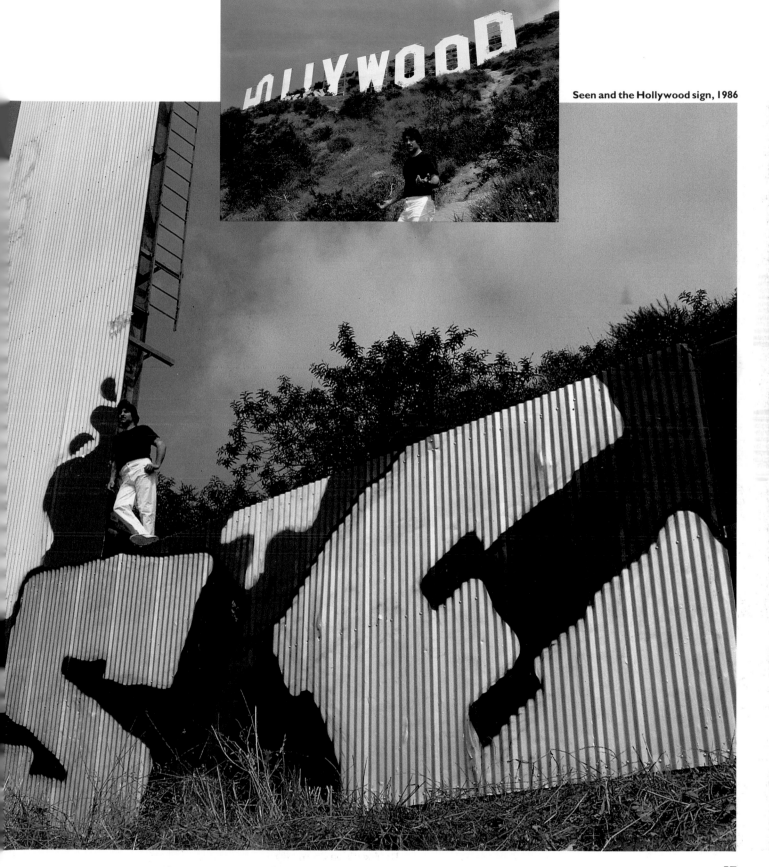

Seen and the Hollywood sign, 1986

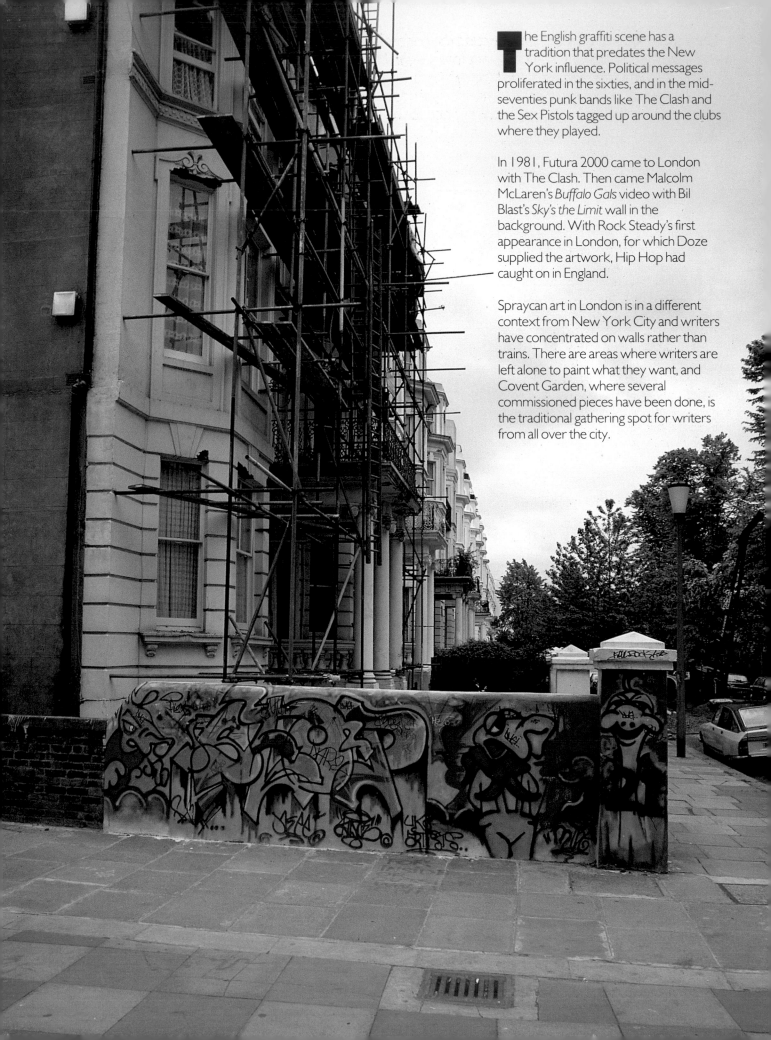

The English graffiti scene has a tradition that predates the New York influence. Political messages proliferated in the sixties, and in the mid-seventies punk bands like The Clash and the Sex Pistols tagged up around the clubs where they played.

In 1981, Futura 2000 came to London with The Clash. Then came Malcolm McLaren's *Buffalo Gals* video with Bil Blast's *Sky's the Limit* wall in the background. With Rock Steady's first appearance in London, for which Doze supplied the artwork, Hip Hop had caught on in England.

Spraycan art in London is in a different context from New York City and writers have concentrated on walls rather than trains. There are areas where writers are left alone to paint what they want, and Covent Garden, where several commissioned pieces have been done, is the traditional gathering spot for writers from all over the city.

"Graffiti in London is concentrated around the Ladbroke Grove area. Why? It could be tradition. The very first piece seen in London, which is by Futura, is done there and it's partly because it's a very good place to work. There's a big elevated motorway going over and it's got large white concrete pillars and it's a very good surface to work on." TAME

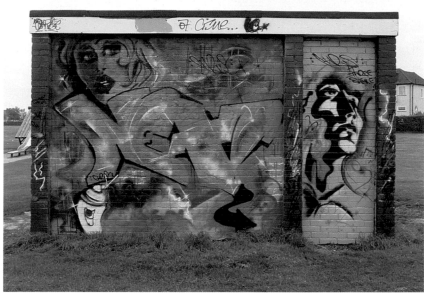

"You're unemployed, graffiti is your joy,
Explain it with your art, you're a million-dollar boy.
Tag on the wall started it all,
Homeboy drawin' in a shoppin' mall.
He's drawin' his pictures and doin' it right,
Taggin' on trains all through the night.
People say you're a vandal but you're my man,
Bustin' out burners with a sprayin' can.
The beauty of art is in each hand,
But the police say you don't give a damn.
In the court of law they're on your back.
The law against graffiti definitely is the wak ...
 and you know that!"
SIR DREW, down with The Crew

Next by Chris, 1986

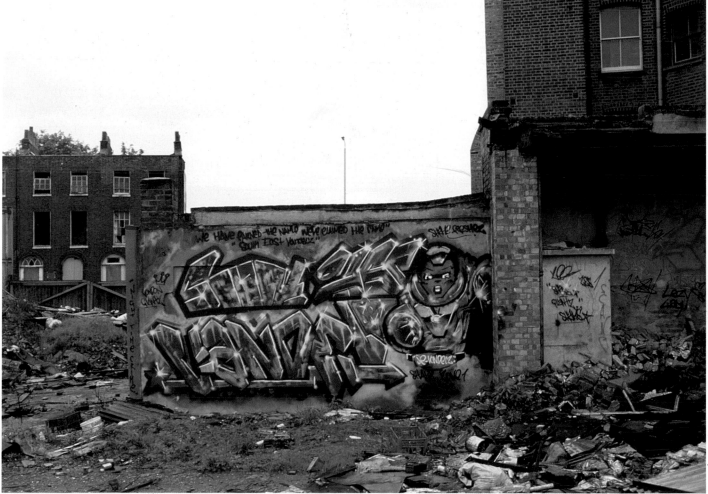

South East Vandals, 1986

Opposite: Stop by UK Artists, 1986

59

At Westbourne Park

"Graffiti in this country has come like a model, an airplane model. It's come here already built. Graffiti in America has taken years to develop, all the styles like your wildstyle and bubble lettering. Over here we haven't added anything to it apart from brushing up on a few techniques." FADE 2

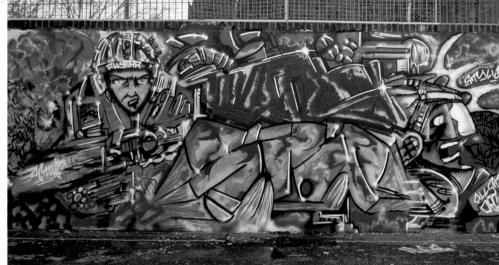

Non Stop by Fade 2, Cane 1, and State of Art, 1986

Mode 2

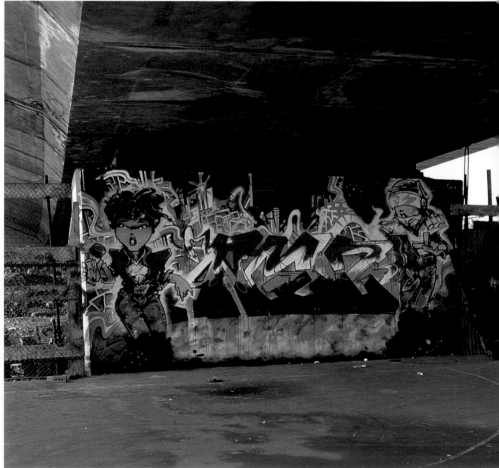

Angelz by The Chrome Angelz, 1985

60

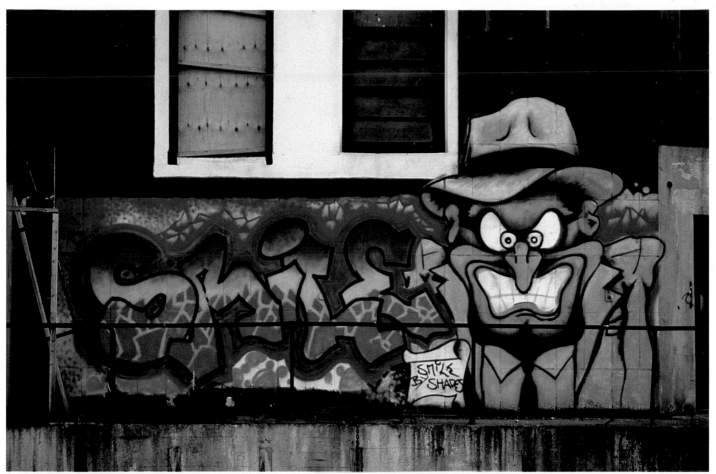

Smile by Shades, 1985

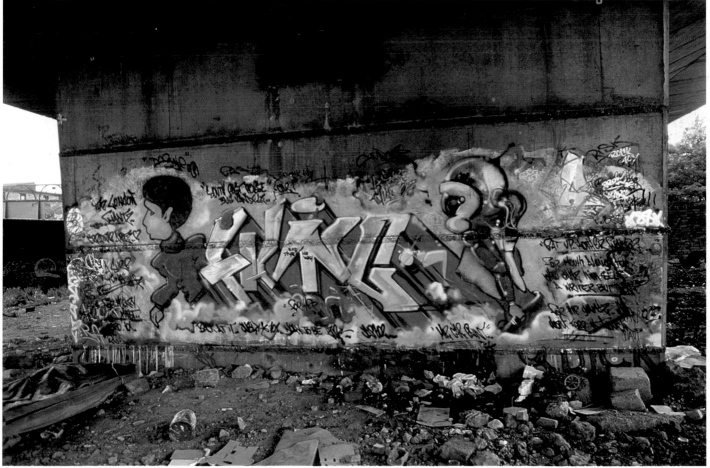

T King by Jap 302, 1986

Pride, Mode 2, Zaki, Bando, and Scribla of
The Chrome Angelz (formerly Trailblazers)

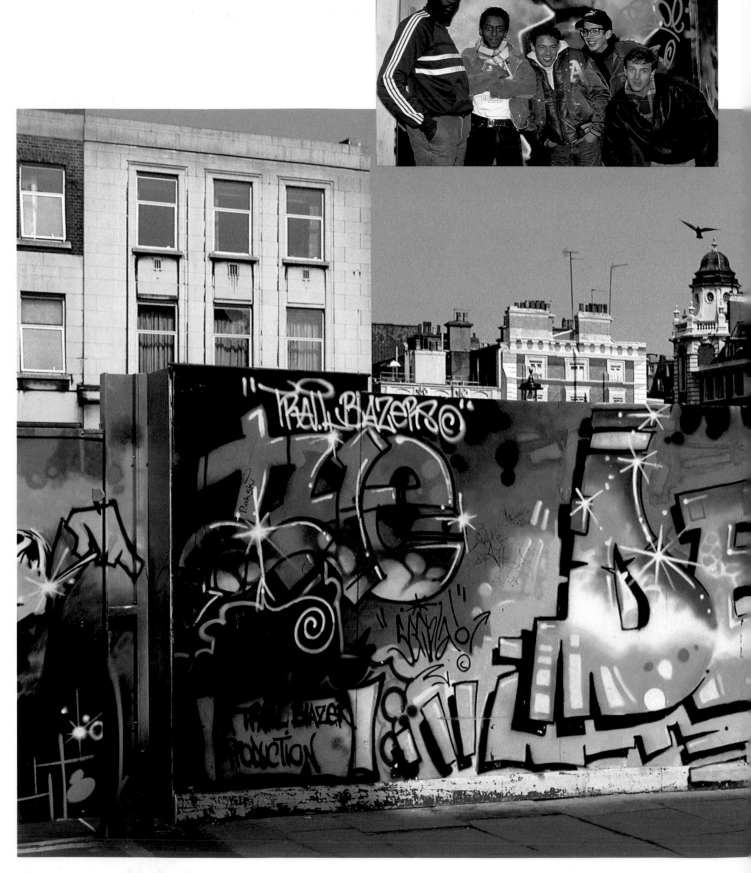

"Kids don't respect us for our art because they 'Spit' over our work. It seems like the only way they're gonna respect us is if we show that we can get people to buy our paintings. That's the only way they're gonna give us some sort of respect. As we're the top, if we just keep going we're bound to get a certain amount of respect in the end, 'cause this is the way the old New York writers got respect. They just kept going. They didn't really care about what people said." PRIDE

Devious by Trailblazers, 1984

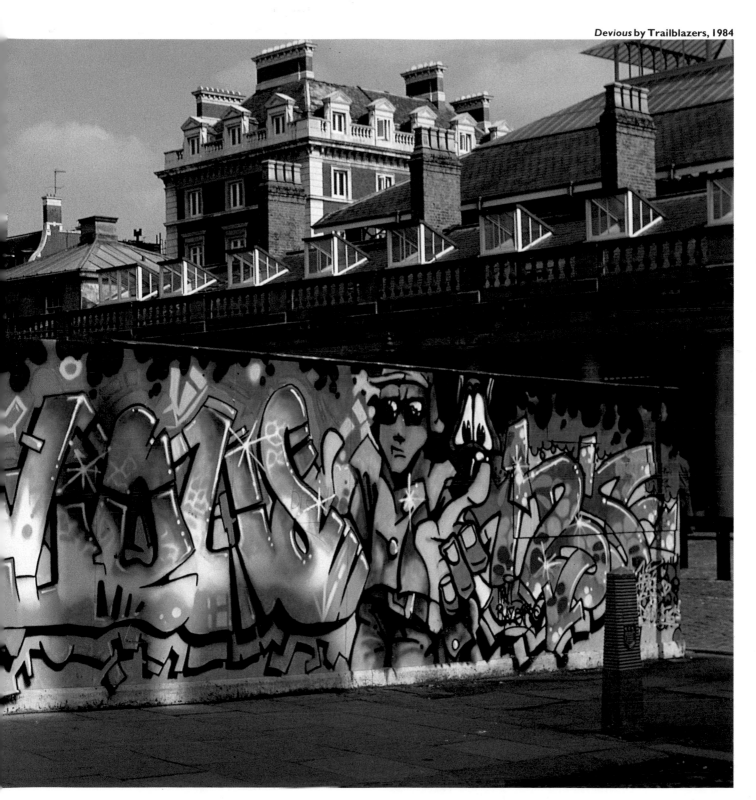

"I think I've paid my dues. I started on the streets painting honestly, without looking at all that publicity and thinking, 'I'll get on that.' . . . I said, I think I've earned the right to make money, 'cause I've spent a year and a half painting without any money, doing work illegally, getting up, being caught twice and fined. I think I'm more honest than other people." 3D

3D, one of the first writers in England, started out in Bristol. Whereas in London the early writers did commissioned work, in Bristol they worked at night, in classic graffiti fashion, on the alert for hostile neighborhood residents and the police.

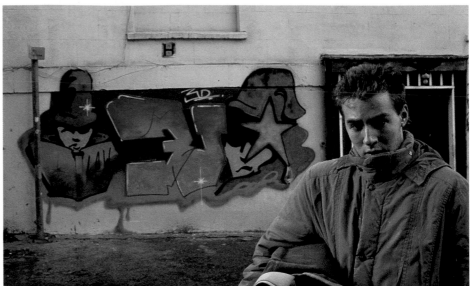

3D, 1985

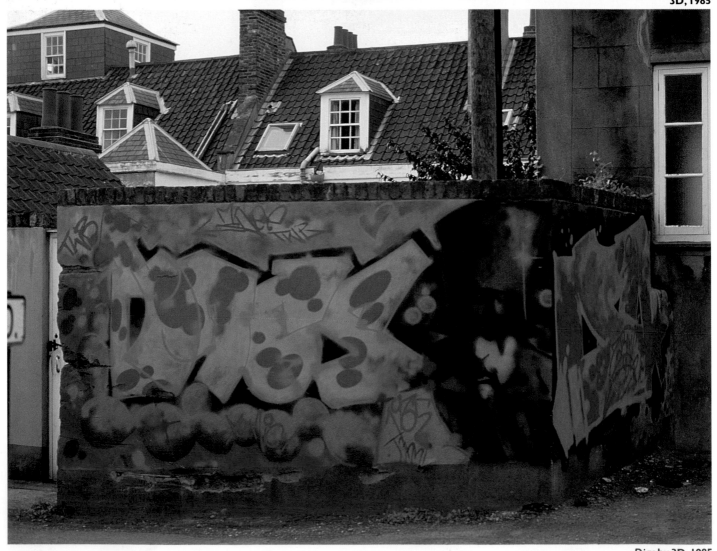

Digs by 3D, 1985

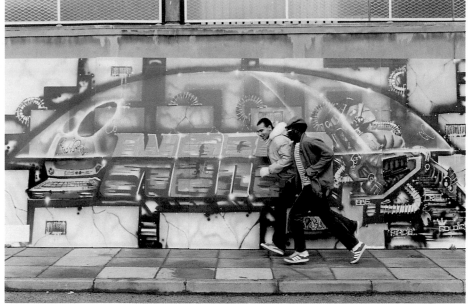

Future World Machines by Goldie, 1986

Goldie, a former break-dancer with The B-Boys crew and a resident of Wolverhampton, believes in working from within the system to achieve his goal of getting his message of social concern out to the public. Consequently, he has worked hard to participate on community projects such as the decoration of the Heathtown school and housing estate where he lives.

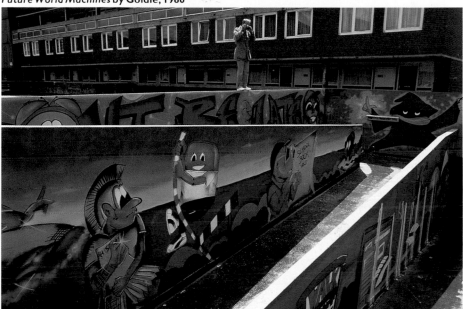

Public art project, Heathtown Estate, by Goldie and Birdie, 1985

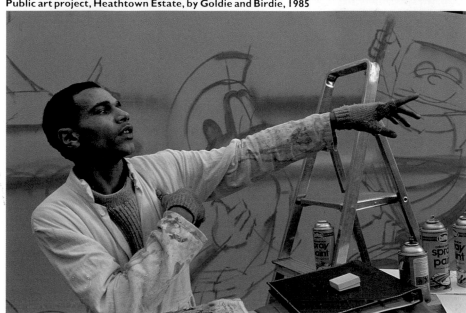

Goldie

"If you've got everybody collaborating on a mass scale, you can't be stopped. You can do anything, man. You can move mountains. If all the kids in this estate were piecing, can you imagine what a beautiful place it would be?" GOLDIE

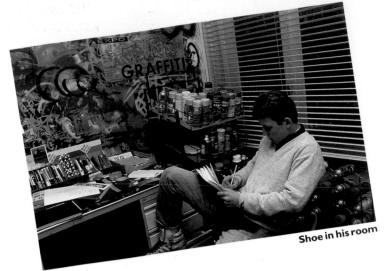

Shoe in his room

Spraycan art in Amsterdam had unique exposure as art entrepreneur Yaki Kornblit became convinced that canvasses by outstanding New York City writers would find a place in art history. In 1983/4 he brought Blade, Blast, Crash, Daze, Dondi, Futura, Lady Pink, Quik, and Ramellzee for personal appearances at sell-out shows. Lee had already exhibited at another Amsterdam gallery. During these showings, local writers got down with the New York kings; some were even vested as members of stateside crews. With all of this exposure, spraycan artists, many from respectable bourgeois backgrounds, appeared in every part of the city. Canal walls (painted while standing on winter ice), motorized transport, park and subway tunnels, railside walls, and construction trailers all became targets for public decoration.

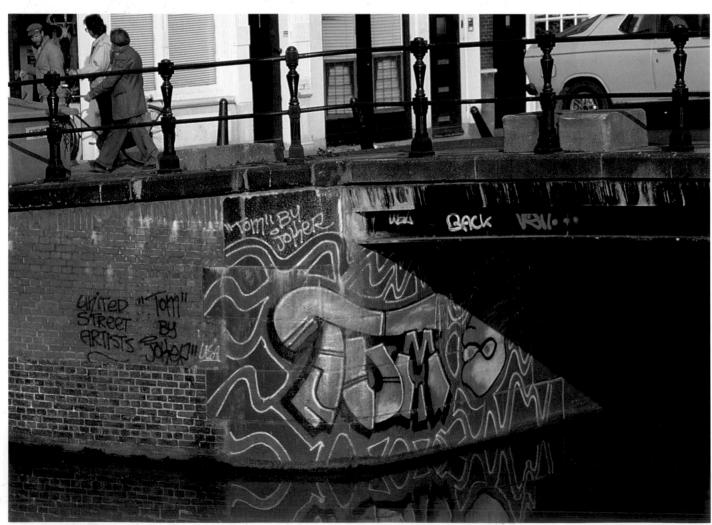

Tom by Joker, 1984

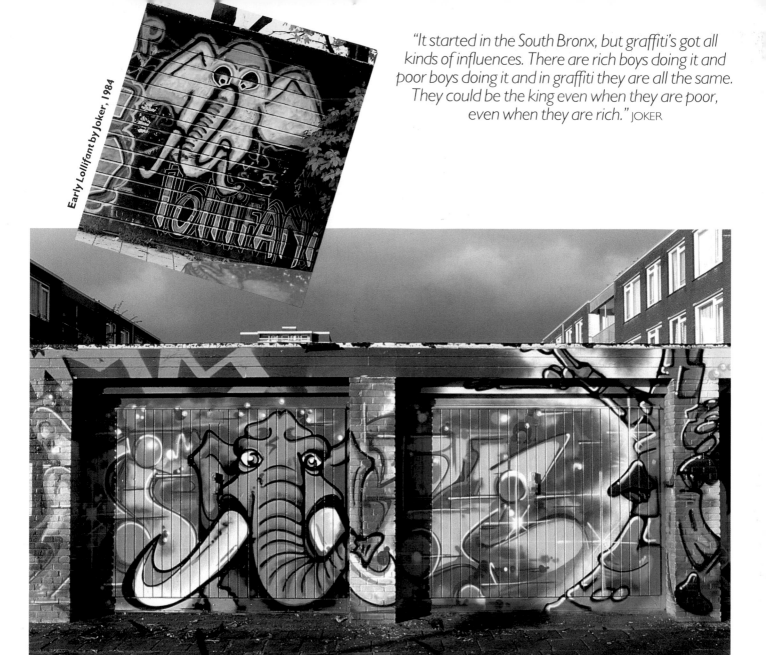

Early *Lollifant* by Joker, 1984

"It started in the South Bronx, but graffiti's got all kinds of influences. There are rich boys doing it and poor boys doing it and in graffiti they are all the same. They could be the king even when they are poor, even when they are rich." JOKER

Later *Lollifant* by Joker, 1985

Joke by Joker, 1985

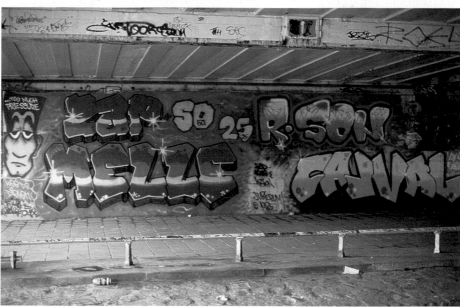

Zap, (50th piece) by Melle, 1985

Canal, (25th piece) by R. Son, 1985

"I think biting is the way to get a style, the way style comes into being. You know, somebody makes something and another one bites it, and after that it becomes a style 'cause everybody takes it over and then it's not biting any more, it's just running a style." DELTA

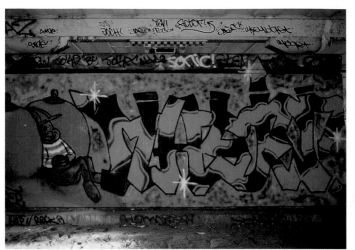

Master, 1985

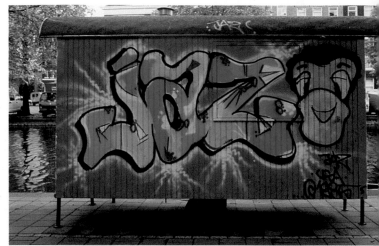

Jaz, 1985

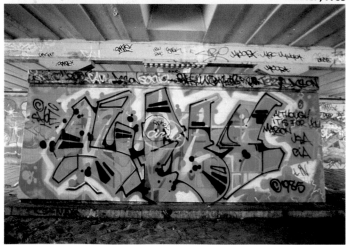

Shoe, 1985

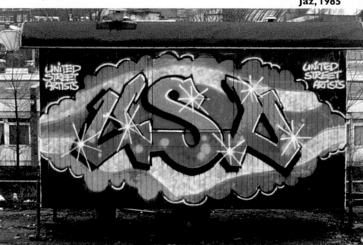

USA by United Street Artists, 1985

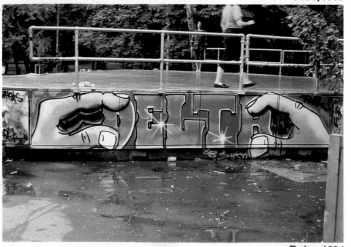

Delta, 1984

Even without all the hype of Amsterdam, in smaller towns like Eindhoven, youngsters' fancy was captured by graffiti featured in the media. Although trains were not the object of their attention, tunnels and underpasses in parks, particularly near train stations, became the local Halls of Fame.

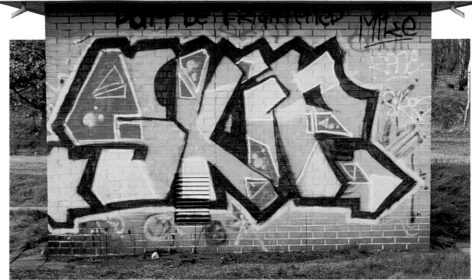

Skip, 1986

"In Eindhoven we've got a 'Hall of Fame' too, but there's almost no room left." FREAKY

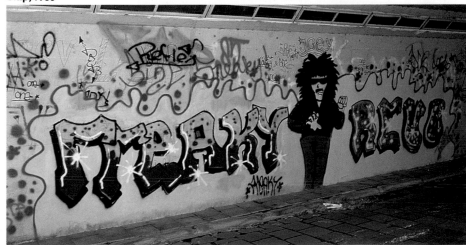

Freaky, 1985

Freaky

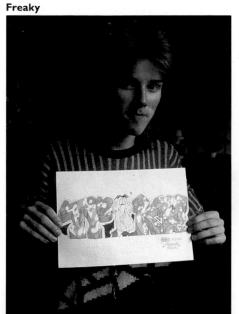

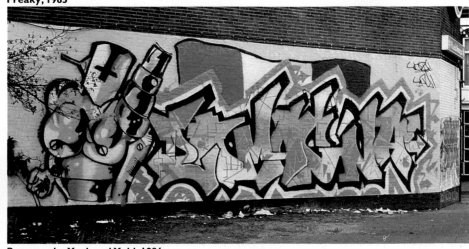

Romagna by York and Yaki, 1986

Writers in Paris have chosen to paint in vacant lots and other deserted areas around the city. The most important of these secluded sites is in the Stalingrad neighborhood, where top crews such as the Crime Time Kings and the Bad Boys Crew gather to paint. Stalingrad is an important gathering place for writers from other countries, such as Britain, the United States, and Holland. Some visiting German writers,

members of a crew with the unlikely name of The Fabulous Bomb Inability, or FBI, said that they were able to indulge their passion for writing only while visiting Paris, since there was no graffiti in their home town in Germany.

Aerosol Art **by Bando, Pride, and Mode 2, 1985**

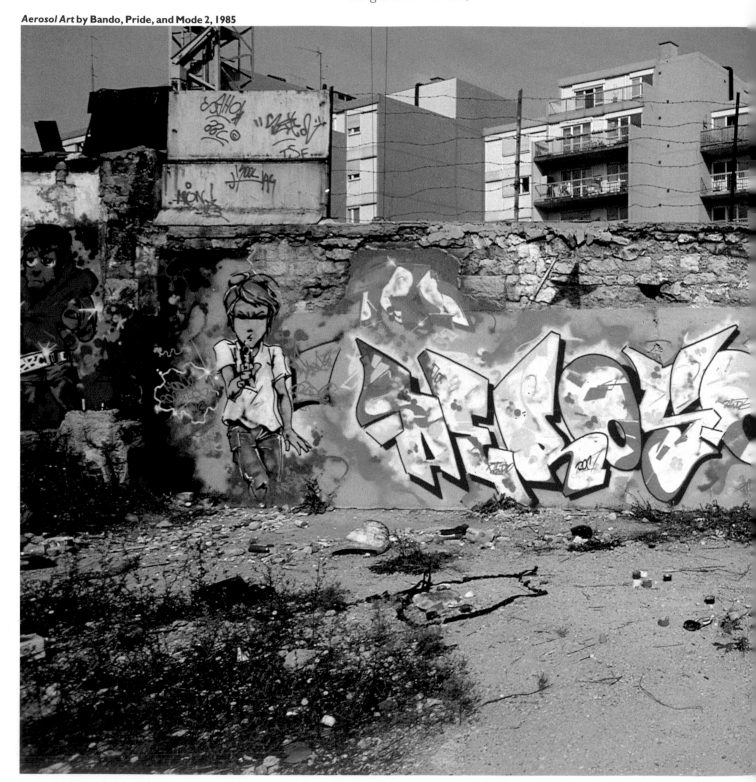

"I make letters because twenty-six letters is enough to define every single thing that exists in the world." BANDO

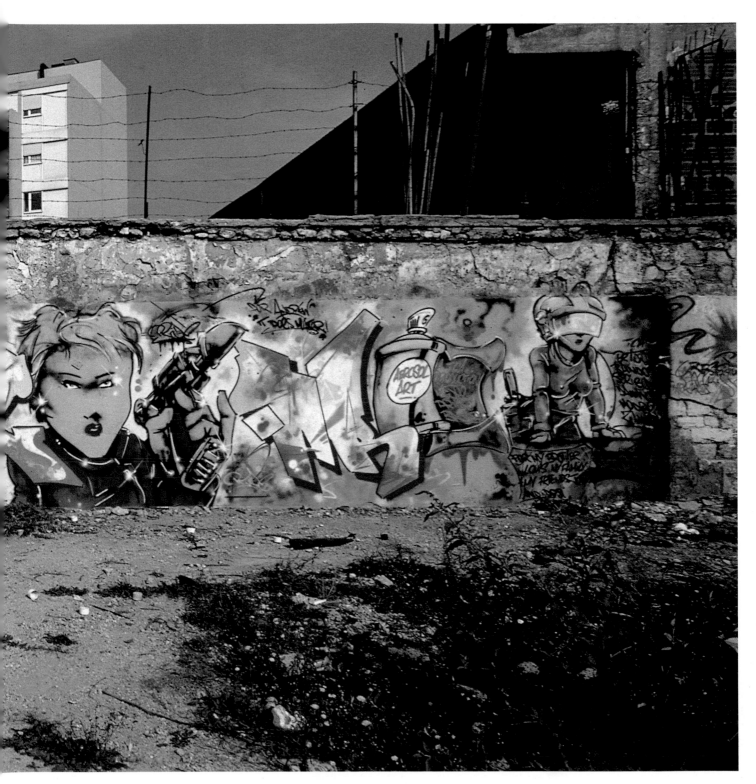

"I have a saying from very long ago. Graffiti is not vandalism, but a very beautiful crime." BANDO

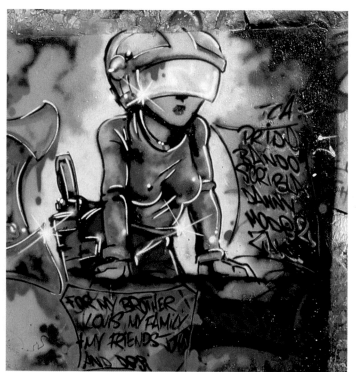 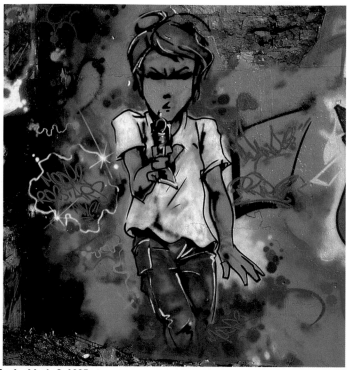

Details from *Aerosol Art* by Mode 2, 1985

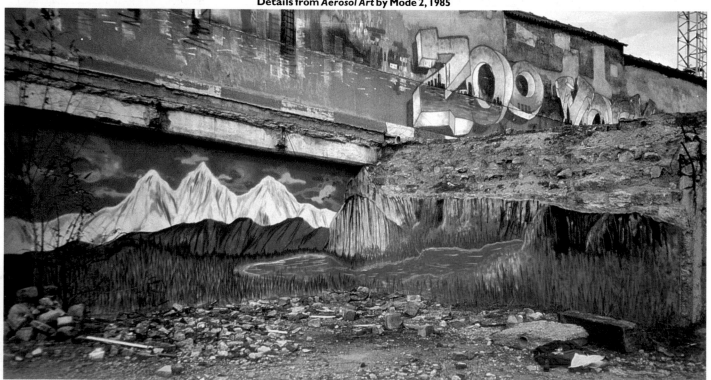

***Zoo York* by Ali, 1985**

***Opposite:* Detail from *TCA, Lucrezia* by Mode 2, 1985**

TCA, Lucrezia by Bando and Mode 2, 1985

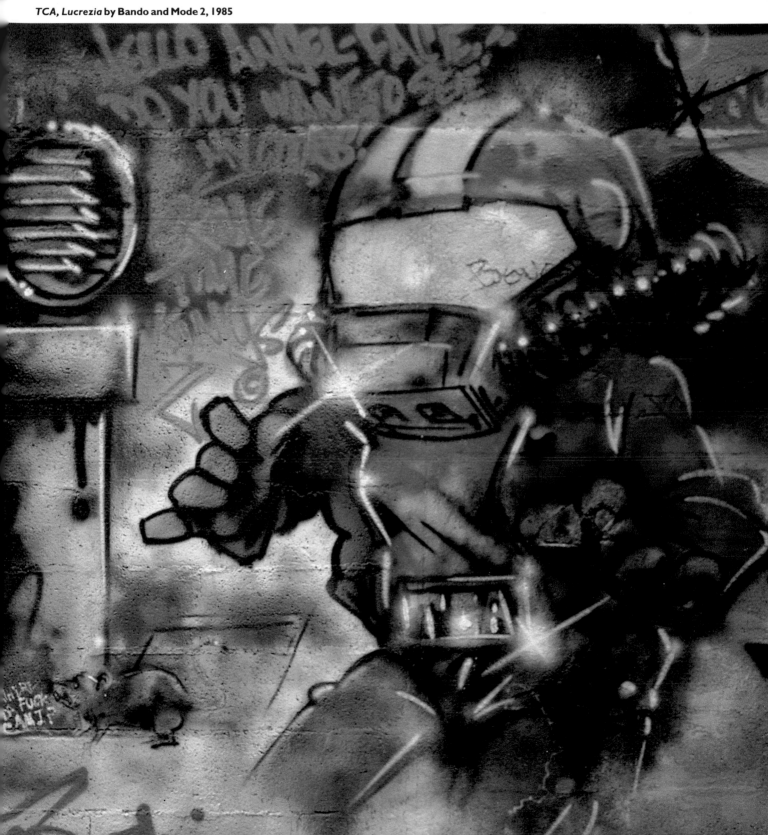

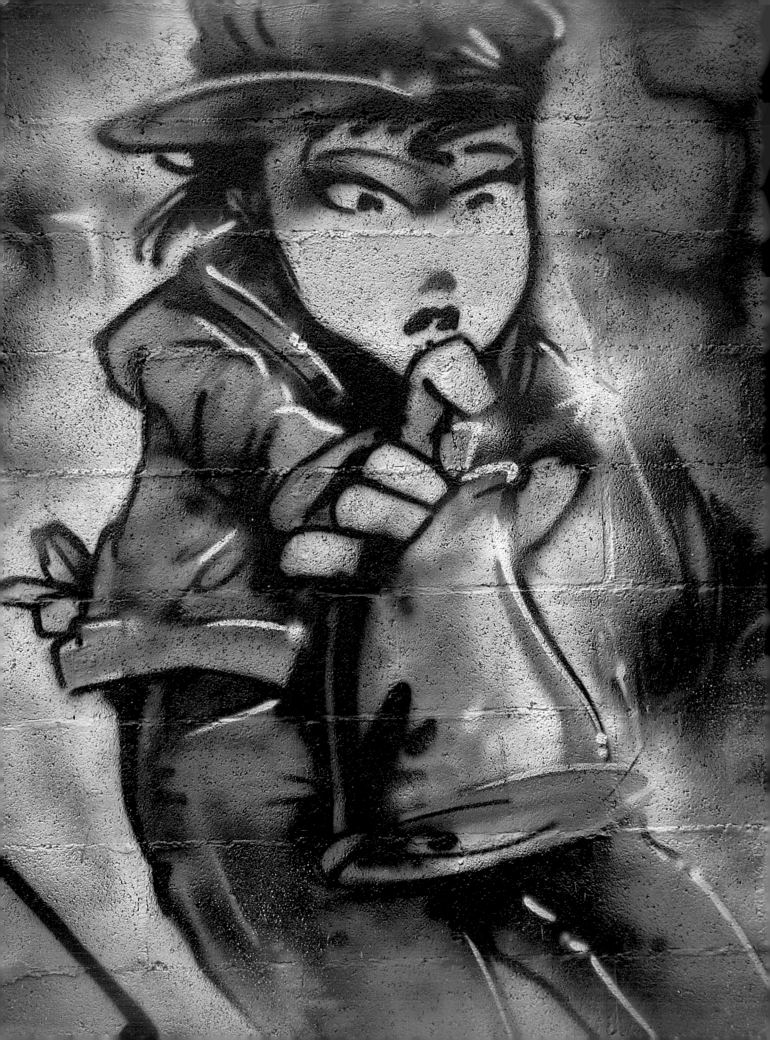

"The first step to follow in the approach toward wildstyle is to keep in mind that you are about to redefine the word 'letter' and at the same time produce a form of calligraphy." BANDO

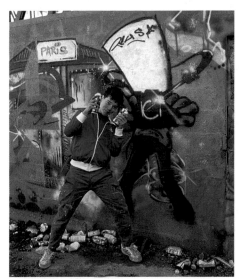

Irus

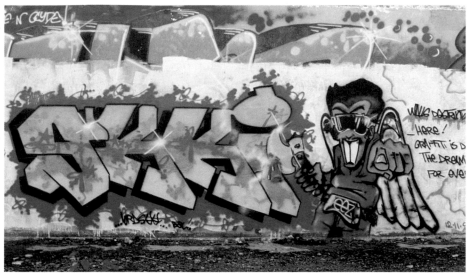

***Walls of Destruction, Part Four* by Skki, 1985**

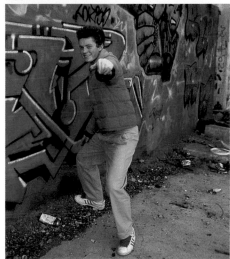

Lokiss

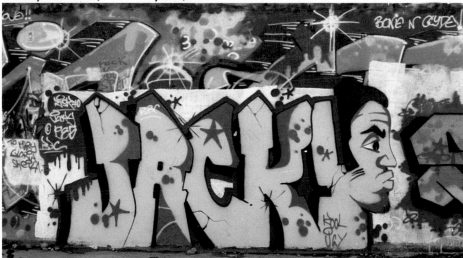

***Rock Against, Part One* by Jacky, 1985**

Opposite: **Detail from *TCA, Lucrezia* by Mode 2, 1985**

Crime Time **by Bando and Mode 2, 1986**

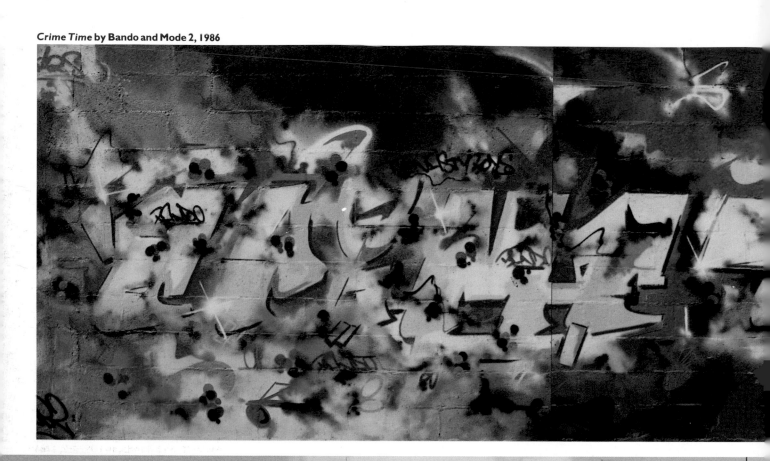

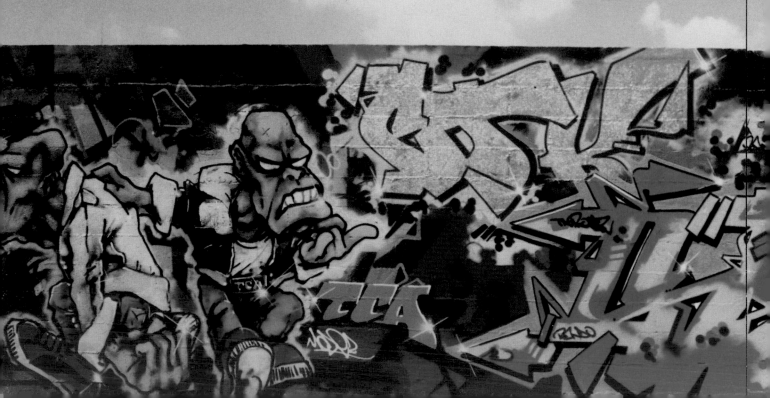

"The first day someone invented a letter. And the first day someone made an effort to make a letter look good. That's when they started. I mean, that's what it's all about." BANDO

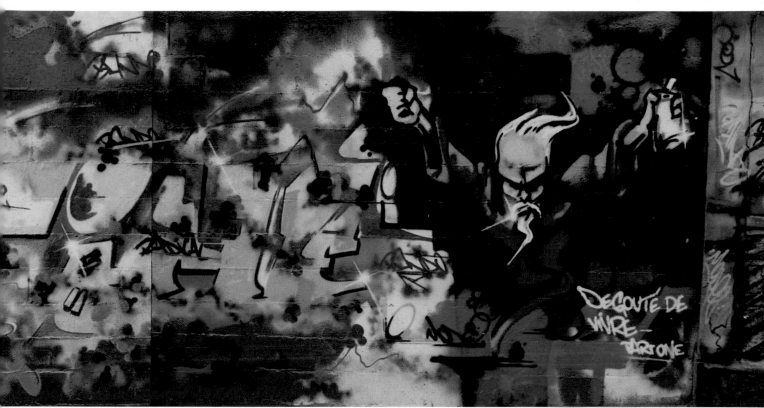

Sens **by Mode 2, Bando, and Steph 2, 1986**

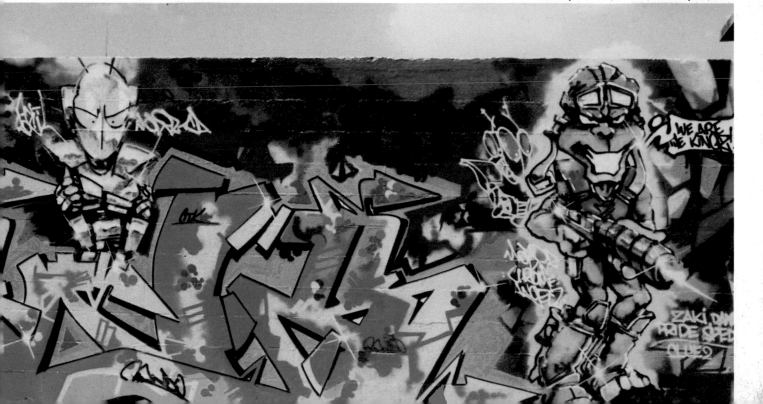

"If you do a drawing and you keep it or you give it away or sell it to someone, it's private, belonging to one person. But graffiti is put in a place in such a way that everyone can enjoy it." CHECHO

Hip Hop arrived later in Spain than in the rest of Europe. Returning émigrés and vacationers from the north were the bearers of the new culture as much as the usual video tapes and magazine articles. While political graffiti has proliferated in the post-Franco era, the development of a New York-style graffiti subculture has been limited by a lack of affordable or easily obtainable paint. What little spraycan art exists is concentrated around public areas where break-dancers gather – shopping centers, metro stations, and in neighborhood playgrounds, where they practice in private.

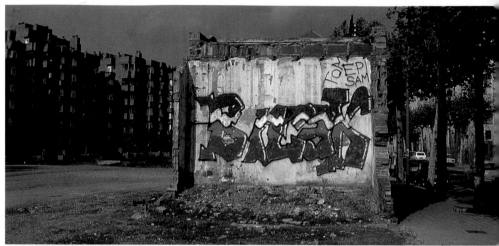

Break by Sam, 1985

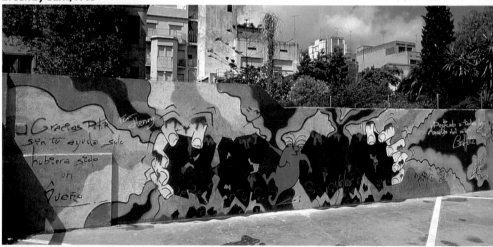

Checho, 1986 Checho

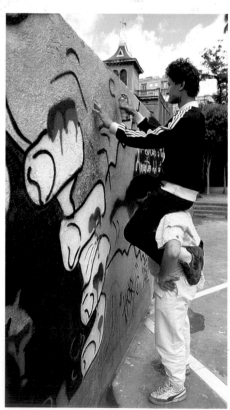

Siko and Beatsky

BERLIN

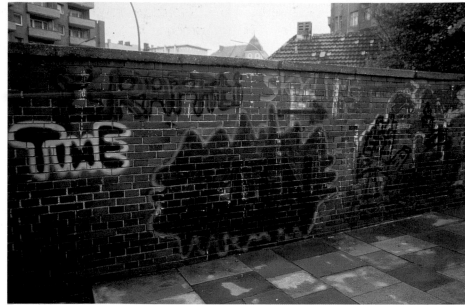

Zeen, 1984

The city has almost no spraycan decoration. What little there is appears in the form of direct English words such as "Beat Street," "Hip Hop," etc., and names of New York City writers such as Lee, Seen, and Skeme.

In its early years, the Berlin Wall was a highly charged political place to make a statement. Today, it has degenerated into a curiosity tourist side-show on the West German side, being filled for miles and miles with "Hi Mary – I made it from Des Moines, Iowa" type of writing with some art intermingled, using spraycan for outlines and paint for fill-in.

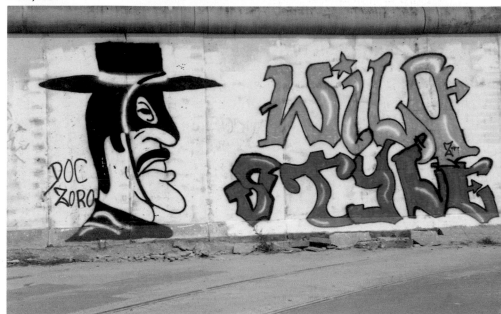

Wild Style by Turkish B-Boys, 1983

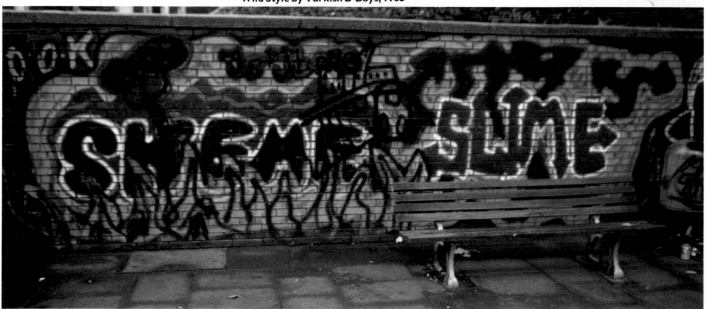

Skeme, Slime, 1984

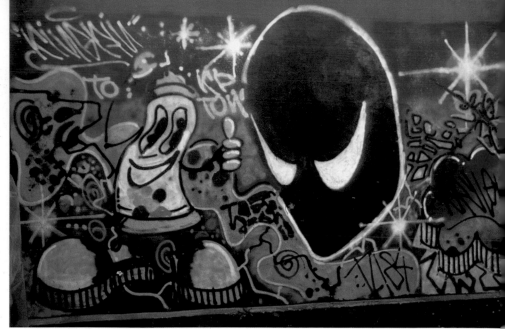

King Pin uses spraycan painting to express his radical views in his small home town of Brühl, a few miles south of Cologne. His early black silhouettes, expressing his view of the brutality to be found in society and in public spaces, has given way to more positive and colorful pieces influenced by the film *Wild Style* and the arrival of Hip Hop culture.

King Pin, 1985

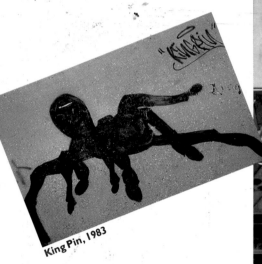

King Pin, 1983

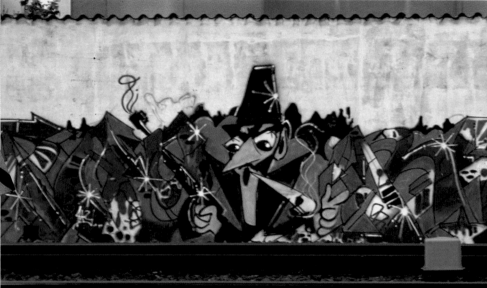

Jay, Remi by King Pin and Jayson Rivera, 1985

"Seeing myself as an artist with ambition and the motivation to change things in life/society with my art, I was confronted with only two possibilities to present paintings: in art galleries or on walls, but only with permission of the owner. Both forms were unsatisfactory, because I saw in both control and restriction. Remaining anonymous and using a synonym for my real identity, I could write where and what I wanted." KING PIN

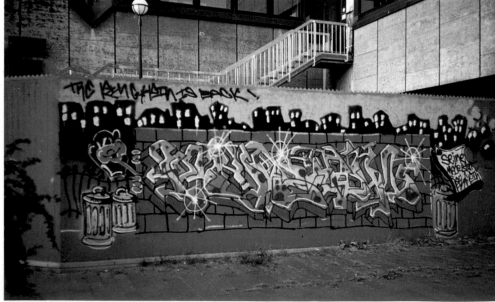

Seine Majestät (His Majesty) by King Pin, 1985

"I think graffiti gives people a new possibility to express their ideas and thoughts. In New York, many people do graffiti because they see a chance to get away from the ghetto when they earn fame. In my opinion, graffiti makes our very serious and gray city (and also New York) more colorful. I like free artistic expression, but I despise political and radical slogans on our walls." MANI

One of the galleries to exhibit graffiti-based art in the mid-eighties was the Grita Insam Gallery in Vienna. During an exhibition of the New York artists Delta, Ero, Phase 2, and Ramellzee, Grita Insam invited Henry to do a presentation. Pieces subsequently began to appear along the Danube, near highways, and on train sites. Energy abated in late '85, but new pieces were done in the spring of '86, at a time when new links were being established with the rest of the graffiti world through visiting writers such as Skki of the Bad Boys Crew from Paris.

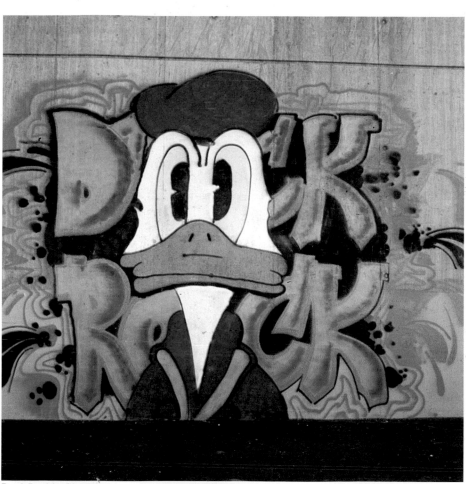

Duck Rock by Masters 4 (now Style Force), 1984

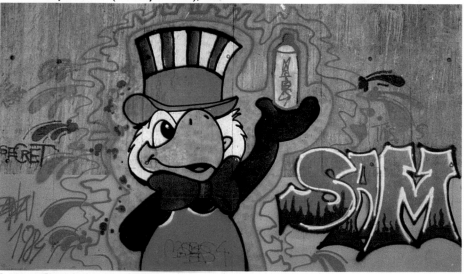

Sam by Masters 4 (now Style Force), 1984

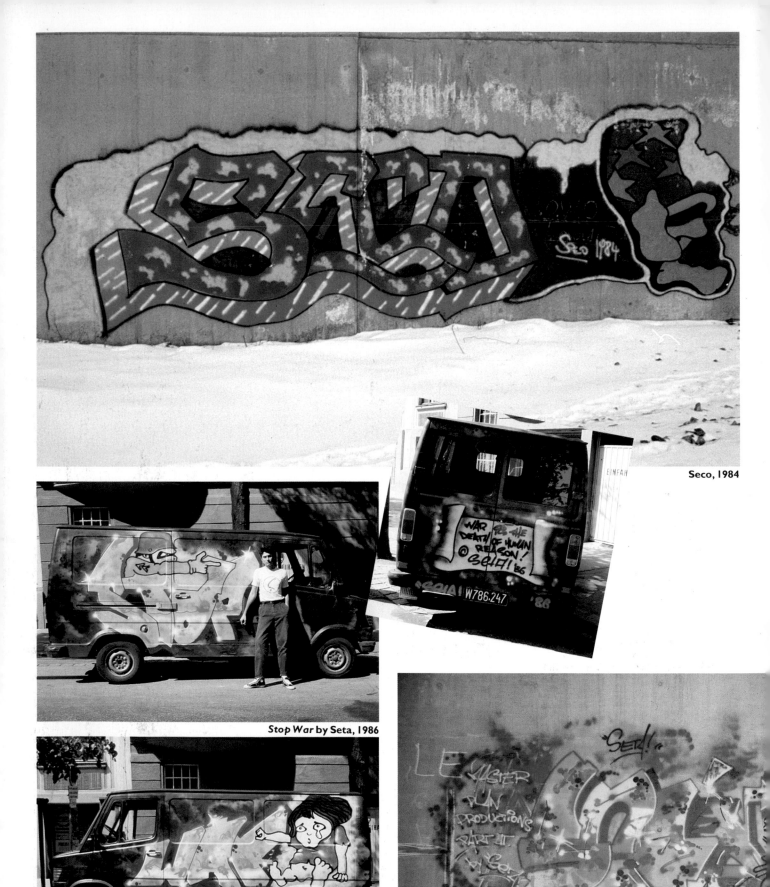

Seco, 1984

Stop War by Seta, 1986

"When I talk with other people about graffiti, I always ask one question — 'Which writers do you know?' I get a good feeling when they say my writer name because I cannot tell them that these are my works. I do graffiti because most people in our city are like robots and I want to show them that you can do happy and colorful things in addition to just eating, sleeping, and working." SECO

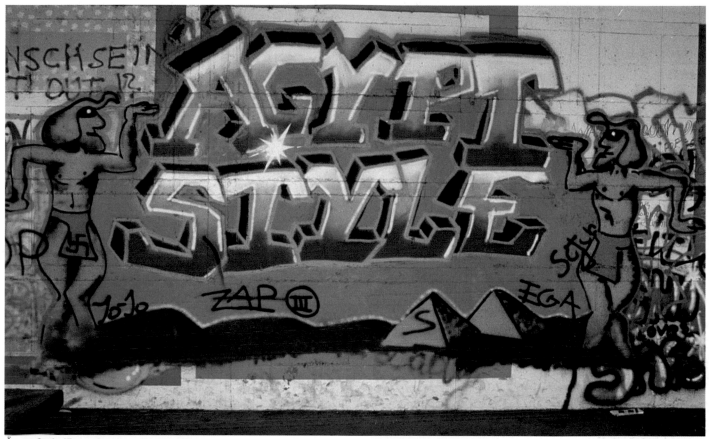

Ägypt Style (Egypt Style) by Zap III, 1984

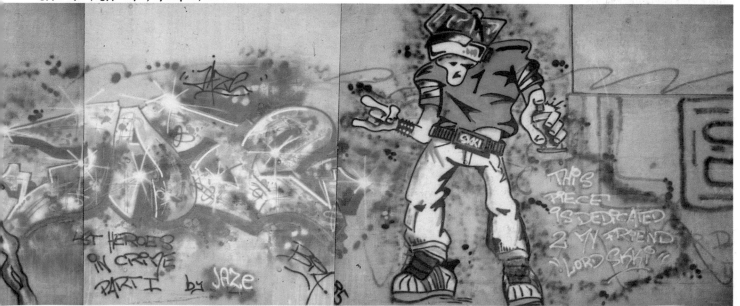

Seta, Jaze, 1986

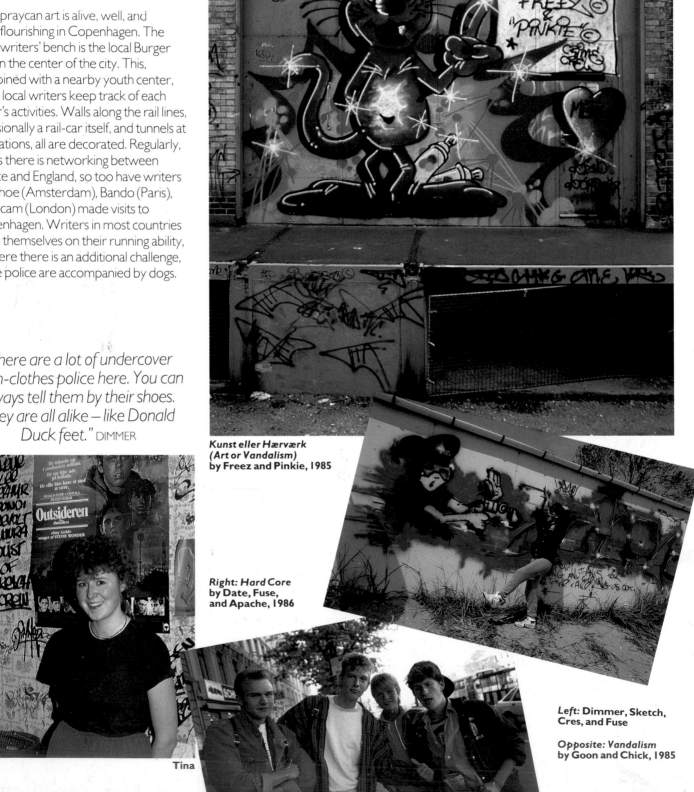

Spraycan art is alive, well, and flourishing in Copenhagen. The writers' bench is the local Burger King in the center of the city. This, combined with a nearby youth center, helps local writers keep track of each other's activities. Walls along the rail lines, occasionally a rail-car itself, and tunnels at rail stations, all are decorated. Regularly, just as there is networking between France and England, so too have writers like Shoe (Amsterdam), Bando (Paris), and Scam (London) made visits to Copenhagen. Writers in most countries pride themselves on their running ability, but here there is an additional challenge, as the police are accompanied by dogs.

"There are a lot of undercover plain-clothes police here. You can always tell them by their shoes. They are all alike – like Donald Duck feet." DIMMER

Kunst eller Hærværk (Art or Vandalism) by Freez and Pinkie, 1985

Right: Hard Core by Date, Fuse, and Apache, 1986

Left: Dimmer, Sketch, Cres, and Fuse

Opposite: Vandalism by Goon and Chick, 1985

Tina

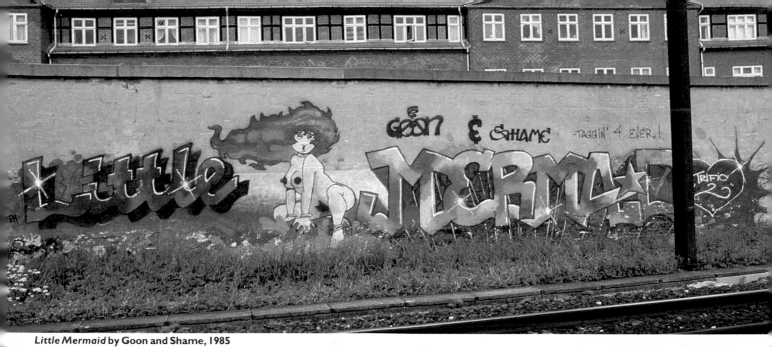

Little Mermaid by Goon and Shame, 1985

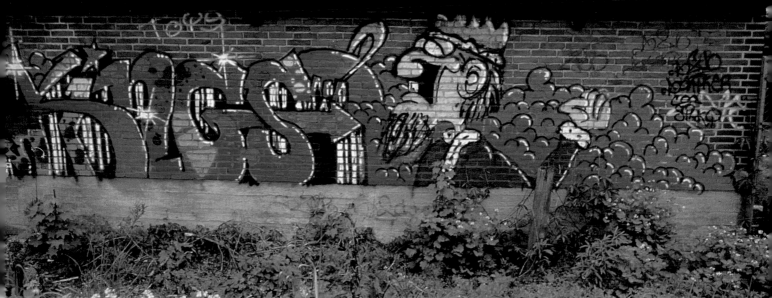

Kings by Bob and Flap, 1985

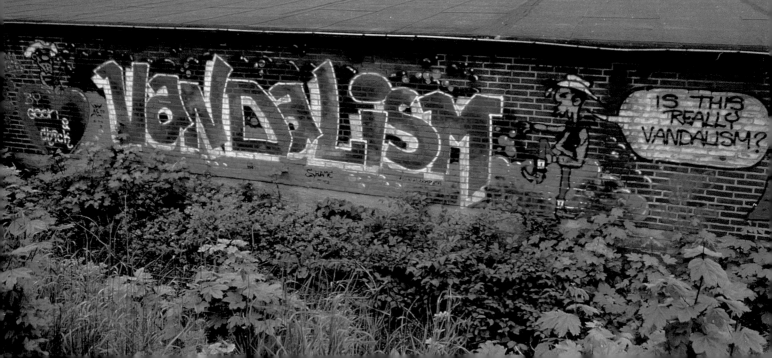

With its great distance from New York and London being balanced by cultural ties, a shared language, and up-to-date media, Australia embraced rap, breaking, and graffiti with great enthusiasm. Writers in Sydney and Melbourne mainly hit the inter-city trains and walls along the right of way.

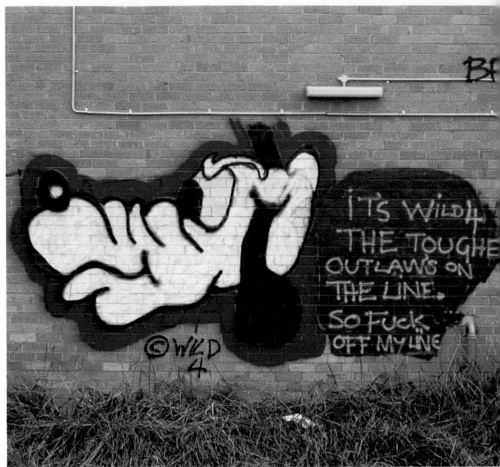

Wild 4 (Melbourne), 1985

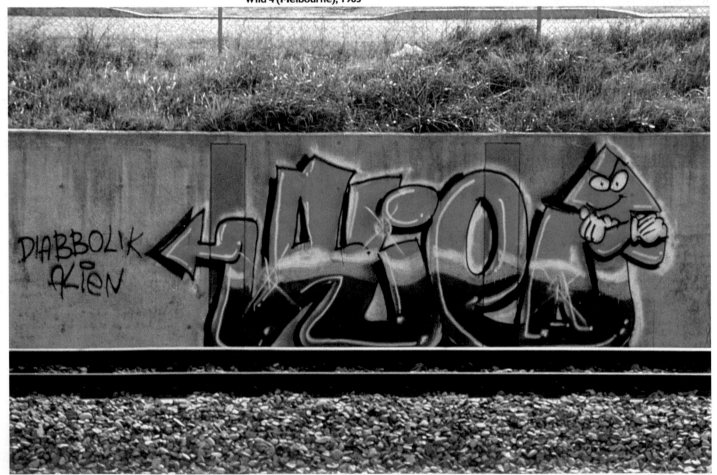

Alien, 1985

"Graffiti in Sydney only started in late 1982. Break-dancing, which started in early '82, has now died out and it is mainly the former dancing groups that have become the graffiti writers. . . . Graffiti in Sydney is no longer about Hip Hop or breaking. It's just names from nowhere and any word or phrase." LEON VASCONCELOS

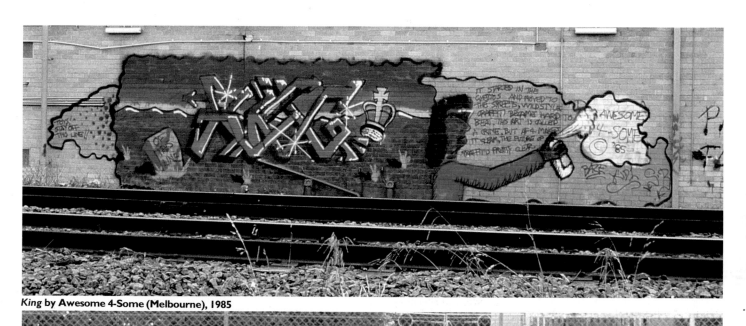

King by Awesome 4-Some (Melbourne), 1985

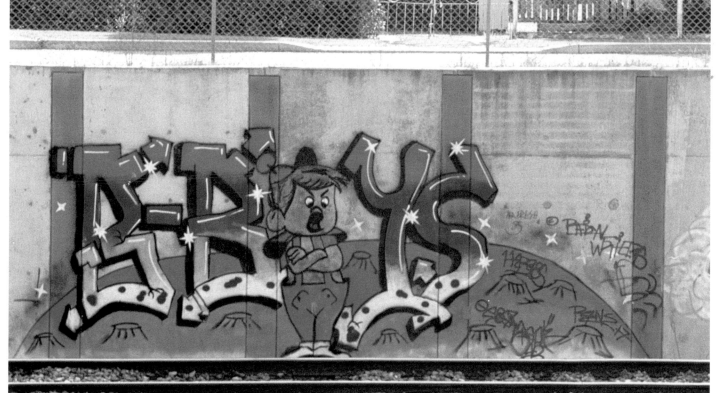

B-Boys by Baby Writers, 1985

In New Zealand, the Maori youth have identified strongly with New York inner-city kids and have recognized in their exuberance and defiance a challenge to the attitudes, tastes, and power of the majority and a reaffirmation of their own strength. The dominant crew in New Zealand is Smooth Inc., who do only legal pieces.

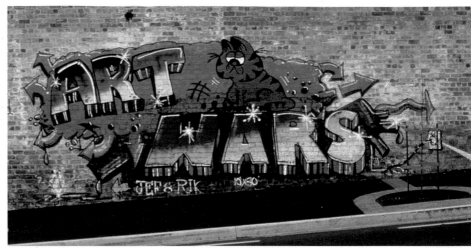

Art Wars by Jef and Rik, 1985

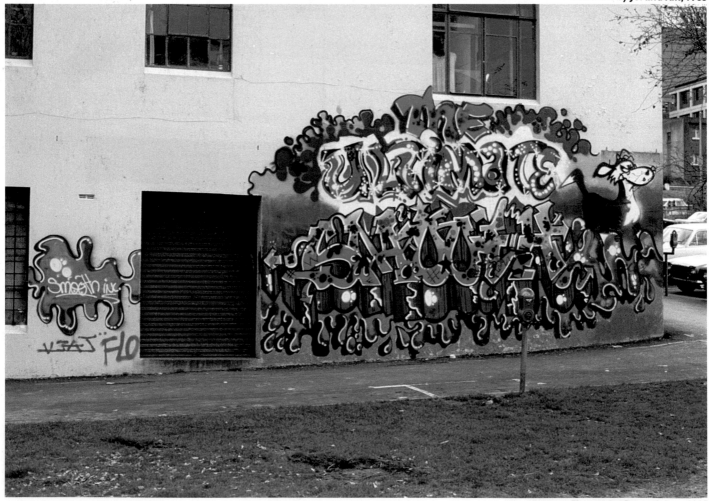

The Ultimate Smooth by Smooth Inc., 1985

"Some crews feel that we've sold out — it's not 'cool' to do pieces for money, to get permission to paint. But they've all given up, and we're still going, putting up our pieces in the heart of the city where everyone can see them." SIMON VAN DER LAAN

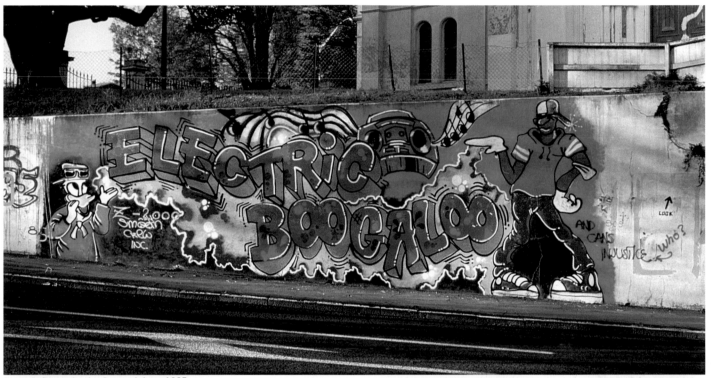

Electric Boogaloo by Smooth Inc., 1985

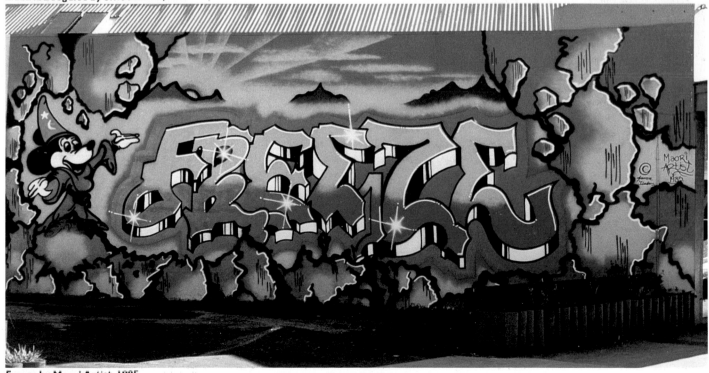

Freeze by Maori Artist, 1985

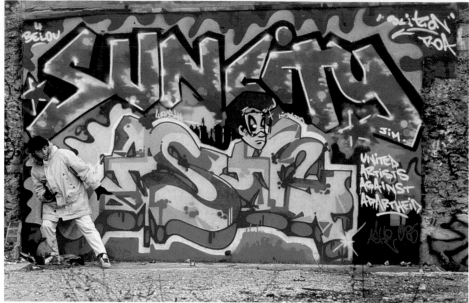

Sun City by Scipion and Saho (Paris), 1986

Most wall messages relating to a change of values in the social system tend to be expressed in word statements. Throughout the United States, Central and South America, as well as in Europe, there is considerable use of walls as public media. This extensive area of political communication also uses spraycan techniques combining art and social-order themes.

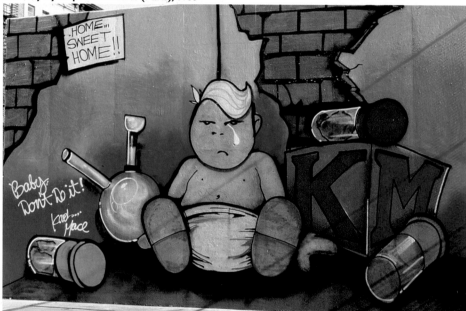

Baby Don't Do It by Kaos and Mace (Manhattan), 1986

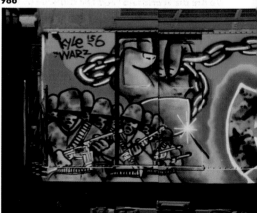

Kyle Wars 2 by Kyle and Jon 156 (Manhattan), 1986

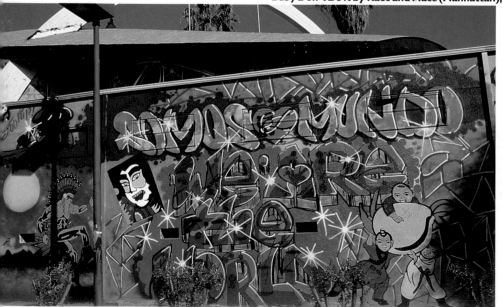

Somos el Mundo (We Are the World) by Crime and Prime (Los Angeles), 1985

"This thing has reached all the way around the world from Harlem to Japan. When has something else had an impact like that on every ethnic group in the entire world? . . . You don't even have to be able to talk English. All you gotta do is get a spraycan and paint something." PHASE 2

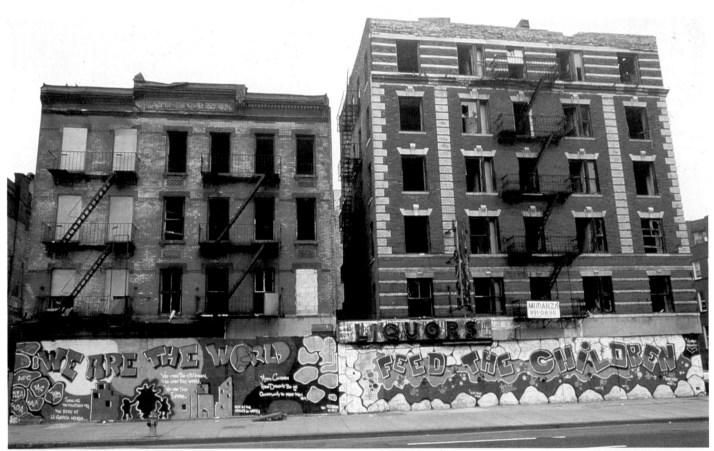

We Are the World and **Feed The Children** by Dive and the TA Crew (Manhattan), 1985

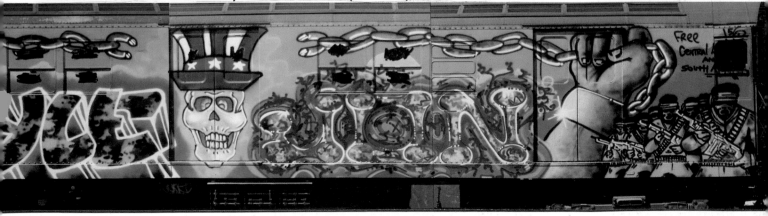

"See, a lot of us died tragic deaths. Graffiti artists live fast and die young. It's part of the way you are. A graffiti artist is different. You ain't a regular person when you're a graffiti artist. It's the way you live . . . a little bit more than most. You're more open, you're 'here I am,' you're louder, you want to show people that you're there, you live a wilder life and people that are seen too much usually die a lot faster, and a lot of them died fast."

TRACY 168

Writers also paint memorial walls in honor of friends whose lives have been cut short.

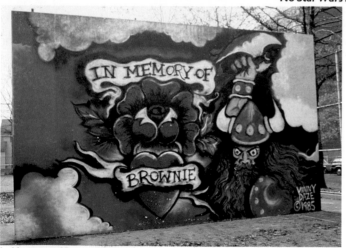

No Star Wars by Josh (Eindhoven), 1985

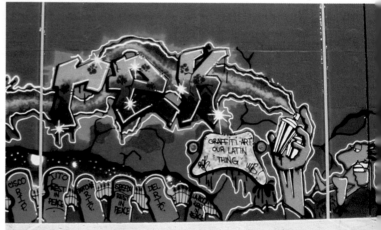

In Memory of Brownie by Vinny Daze (The Bronx), 1985

In Memory of Cisco, Tito, Butchie, Speedy, Del, Laroo by Rek (Brooklyn), 1984

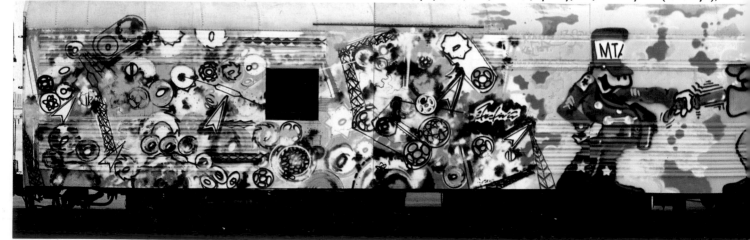

92

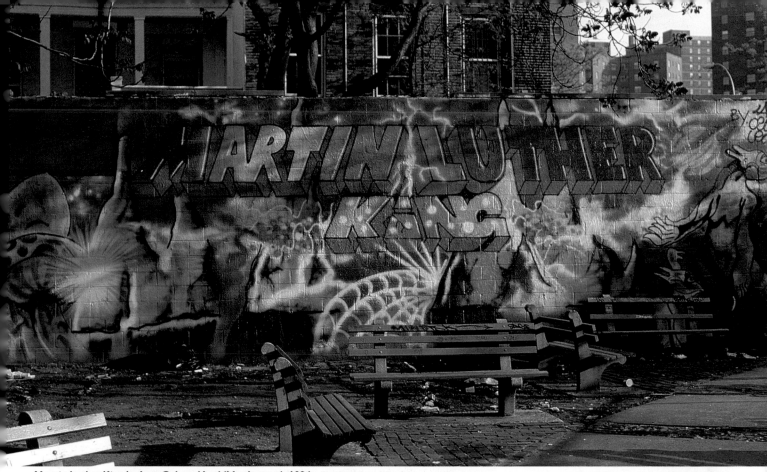

Martin Luther King by Lac, Cel, and Led (Manhattan), 1984

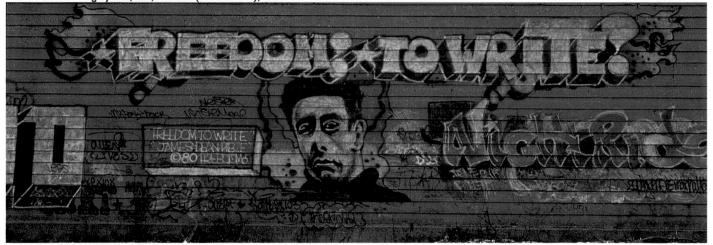

Freedom to Write (for James Dean) by Freedom (Manhattan), 1980

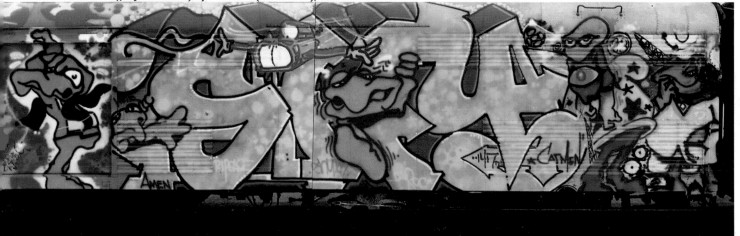

Shy 147 by Futura 2000, Kel 139, and Mare (Detroit, Artrain), 1986

CREATION
OF A MURAL

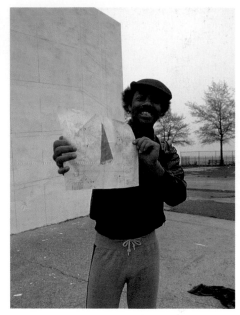

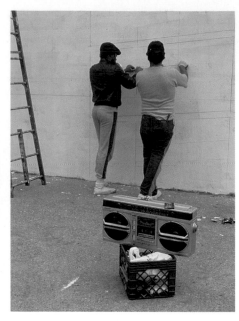

Blade and Maze One had a plan. Find a giant monumental wall, get permission to do it, document the process, and at the finish return the wall to its original, drab condition – if that became a necessary part of the agreement.

The location was a paddle-ball court at Orchard Beach in the Bronx on Long Island Sound. The wall measured seventy feet by sixteen.

Normally, a piece is outlined first with rough spray lines. Then comes the fill-in and, finally, the details and finished outline. This piece was unusual in that the outline was done in chalk – actually measured on the wall – and then came the spray fill-in. Lastly, the details were added and the outlines completed. As Maze said, "I'm in construction and understand angles and perspective."

The piece was conceived as two high towers composed of block letters spelling out the names. There is a black, triangular solid floating above the horizon, held by a hand. "It means whatever you want to see," said Blade. "The reason I use the name is that's what graffiti is all about. The name is the main image. Without the name, you'd paint a picture and sign your name in the corner. Either way, everyone knows you from here to Brooklyn, everywhere."

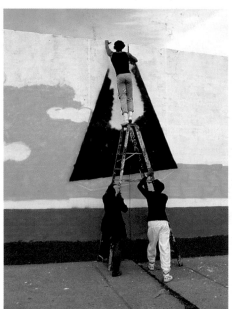

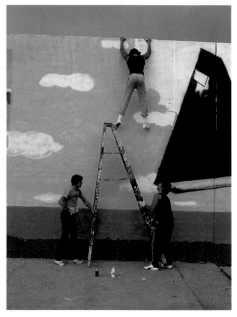

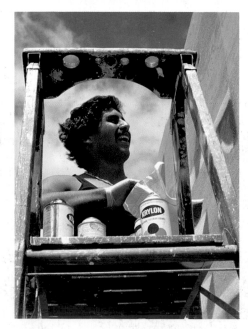

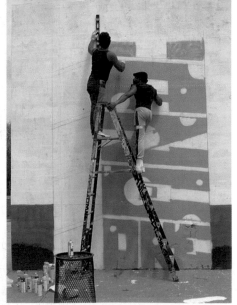

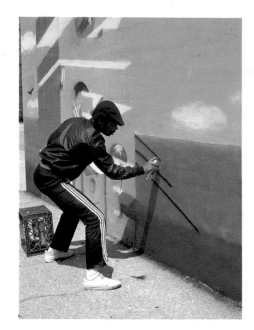
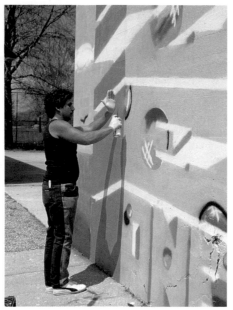
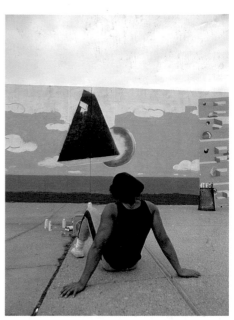
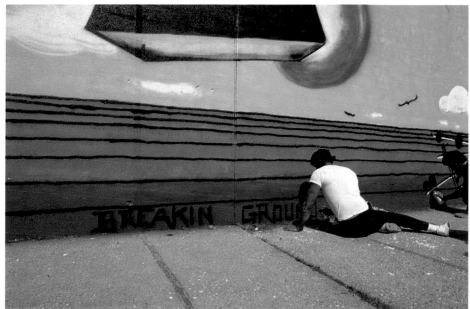
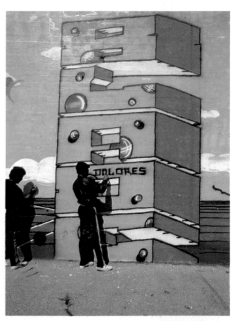
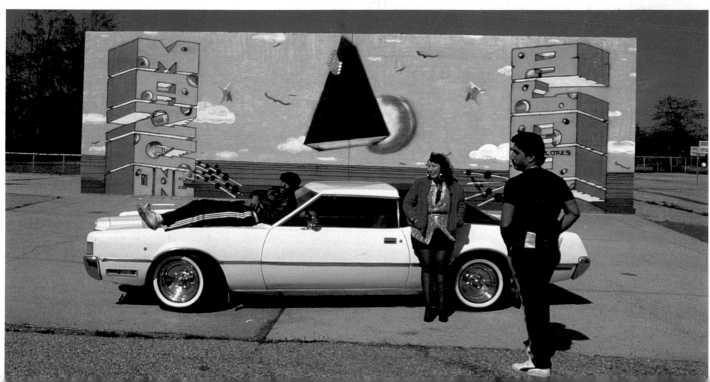

Ken, Nicer, 1986

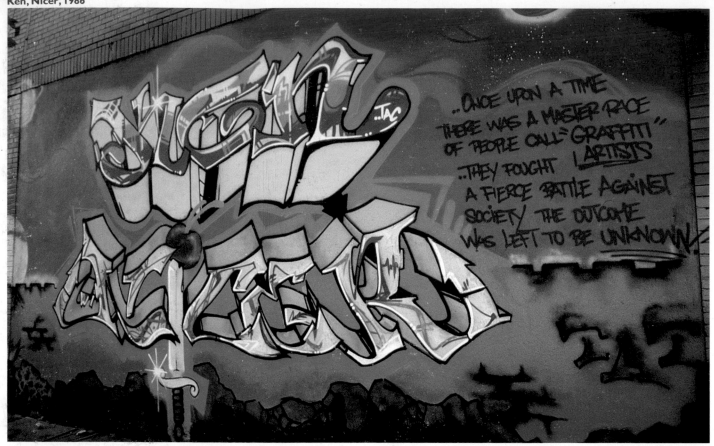

JAMES PRIGOFF graduated from the Massachusetts Institute of Technology as an industrial engineer, pursued a successful business career, and is now a consultant in the field of crisis management. He writes and lectures on community murals and has photographed one of the major documentations of mural art in the United States. As a peace and political activist, he helped to found the Peace Museum in Chicago, and, as an athlete, has been eight times national squash tennis champion of the U.S. Jim is married with four children and lives in San Francisco.

HENRY CHALFANT studied at Stanford University, where he majored in classical Greek. For ten years he has documented all aspects of Hip Hop culture in the United States and Europe and is recognized as the foremost archivist of graffiti and spraycan art, which he has recorded from its earliest stages. He is co-author of the definitive book on the New York graffiti phenomenon, *Subway Art,* and co-producer of the prizewinning television documentary, *Style Wars.* He is also an accomplished sculptor. Henry lives in New York with his wife and two children.

Barnsley College
Honeywell
Learning Centre